IMAGES
of America

BUFFALO'S HISTORIC
STREETCARS AND BUSES

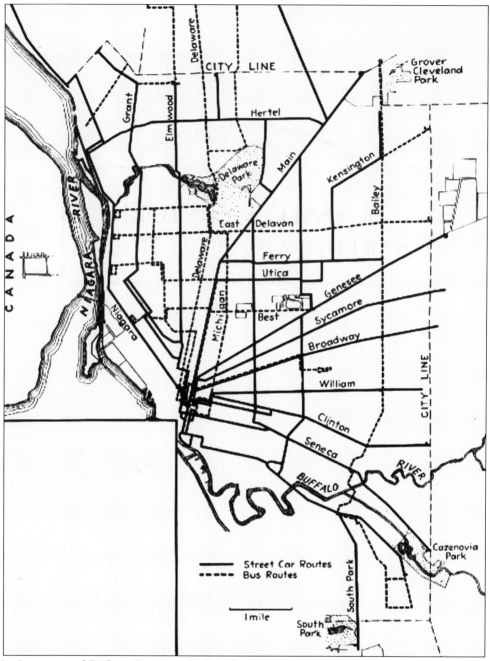

An International Railway Company Buffalo division map of 1939 is pictured here.

On the cover: On June 1, 1948, International Railway Company No. 138, a streetcar built in 1917, and a 3100-series Mack bus, built in 1941, pause in front of the Liberty Shoes store on Main Street near Huron Street in downtown Buffalo. By 1952, David Abrams, the owner, estimated he had sold over 25 million pairs of shoes. This equated to about 80 pairs of shoes for each resident of Buffalo. Today Metro Rail's Huron station serves this area, but not a single component from this photograph remains. (Author's collection.)

IMAGES

of America

BUFFALO'S HISTORIC
STREETCARS AND BUSES

D. David Bregger

ARCADIA
PUBLISHING

Published by Arcadia Publishing
Charleston SC, Chicago IL, Portsmouth NH, San Francisco CA

Printed in the United States of America

Library of Congress Catalog Card Number: 2007933907

For all general information contact Arcadia Publishing at:
Telephone 843-853-2070
Fax 843-853-0044
E-mail sales@arcadiapublishing.com
For customer service and orders:
Toll-Free 1-888-313-2665

Visit us on the Internet at www.arcadiapublishing.com

*To my parents and good friends, especially the late Gordon J.
Thompson and Edward J. Tanski, who recognized and nurtured my
interest in public transportation.*

CONTENTS

ACKNOWLEDGMENTS

I would like to thank the late Walter McCausland, longtime director of public information for Niagara Frontier Transit System and predecessor companies, and his assistant Irene M. Engler for preserving so many of the photographs presented herein. Special mention is also due to the graphic and reproduction departments of the Niagara Frontier Transportation Authority.

I also wish to thank the late William Kunz and the late Edward J. Tanski, both former vice presidents, mechanical department, Niagara Frontier Transit System, and affiliated companies, for their endless patience and willingness to share personal experiences and professional observations.

Bruce McCausland, grandson of Walter McCausland, graciously shared his grandfather's personal collection of vintage Buffalo area transit photographs and then put his heart and soul into preparing each individual photographic image for reproduction.

Special mention is also due to Bruce Korusek of Richmond, Virginia, who graciously provided several interesting photographs, technical articles, and Mack bus advertisements from vintage trade journals.

Lastly I will always be grateful to my special friend Sally L. Mahnk for her endless patience, support, and understanding throughout this entire project.

I do not remember riding any International Railway Company streetcars, but I vividly recall the sight and sounds of the first one I saw. To this two-year-old boy, it was unforgettable. As I grew older, I saw much of Buffalo by looking through the windows of countless Niagara Frontier Transit buses.

Along the way I met many fine employees. Their dedication, patience, professional pride, understanding, and willingness to always answer my questions eventually inspired me to pursue a career in public transportation.

They all deserve a proper expression of gratitude.

This book is also dedicated to my good friend and mentor, the late Gordon J. Thompson, whose visionary efforts continue to serve public transportation in Buffalo.

INTRODUCTION

Once upon a time Buffalo was a great American city. A great city deserves a great network of public transportation. In that regard, residents were well served.

The International Railway Company (IRC) never attained the recognition it deserved. It was a large diversified network of public transportation. Before ownership of private automobiles became common, IRC functioned as the family car by providing streetcars for every occasion. Local street railway service was provided in the cities of Buffalo, Niagara Falls, and Lockport. Suburban service was available to the Tonawandas and Lancaster. Two interurban lines operated, one to Niagara Falls, the other to Lockport and Olcott Beach where IRC owned and operated an amusement park and hotel. Later a third line, the Buffalo Niagara Falls High Speed Line, was built. Electric freight service was offered between North Tonawanda and Lockport. The world's most famous scenic electric railway, the Great Gorge Route, served the American and Canadian sides of Niagara Falls and connected two great nations via two IRC-owned international toll bridges that spanned the Niagara River at Niagara Falls and Lewiston-Queenston.

Today's universal concept of single-end transit vehicles with front entrance and fare collection was created and perfected in Buffalo. In 1923, when automobiles were well on their way to become IRC's most formidable competitor, IRC created a bus-operating subsidiary, the International Bus Company (IBC). IBC utilized developing bus technology to serve neighborhoods previously without any transit service whatsoever. Within 10 years, IBC grew from a single bus operating one route to a seven-route 85-bus system with 10 million annual riders. This valuable experience allowed IRC to redefine its role as a responsible corporate citizen.

During World War II, IRC's per capita transit patronage was second only to that of Washington, D.C. After 1950, IRC reorganized as the Niagara Frontier Transit System (NFT) and, blessed with competent staff and many dedicated career employees, transformed itself into one of America's most progressive and profitable bus systems.

Inevitable urban sprawl helped bring about the decline of traditional central business districts in most American cities. Buffalo was no exception. As downtown lost its allure, so too did NFT. Transition from private to public ownership occurred in 1974. A mere 10 years later, electric transit service returned to the streets of the city. Some people might say it was the streetcar's revenge.

One

HORSECARS, EARLY ELECTRIC OPERATIONS, AND THE PAN AMERICAN EXPOSITION

On August 10, 1859, the Niagara Street Railroad Company, Inc., was chartered to construct and operate a horsecar line along Niagara Street to Black Rock. A second entity, the Buffalo Street Railroad was formed the following year to serve Main Street. Construction of both routes began in May 1860. The Buffalo Street Railroad Company commenced operations on June 17. Eleven days later, the Niagara Street Railroad began service from Main Street to Fort Porter. Soon other lines appeared on Batavia Street (later known as Broadway) and Genesee Street where turntables were installed at each end of the single-track route thereby eliminating the need to have horses change directions.

Expansion continued in the 1870s and 1880s. Soon more than five million passengers were carried each year.

On March 11, 1888, tests with three battery-powered streetcars imported from Liverpool, England, began. Their operating range and amount of time needed to recharge batteries were each about four hours. Operating costs were high and the experiments ended.

On July 20, 1889, an experimental electric streetcar route operating from Main Street and Michigan Avenue to Delaware Park via Harvard Place, Delavan, Delaware, and Forest Avenues opened. It was an instant operating success. On December 24, 1890, permanent operation of electric streetcars began on Main Street between Cold Spring and the New York Central Railroad Belt Line near Jewitt Parkway. On June 29, 1891, a second line on Niagara Street from Main Street to Hertel Avenue opened. Other conversions and expansions followed until the last horsecar route, Jefferson Avenue, was electrified on November 10, 1894.

In Niagara Falls, 22 miles downriver, tracks were laid on Falls, Second, and Main Streets in 1883. After electric power arrived on March 9, 1892, other routes were added. A Canadian sightseeing-trolley route from Chippewa to Queenston, Ontario, opened on July 1, 1893. In 1895,

tracks were extended across the Fallsview and Queenston international toll bridges and service operated in conjunction with the Niagara Gorge Railway on the United States side. This Great Gorge Route became the world's most famous and only scenic electric railway.

Additional lines appeared in the Tonawandas, Williamsville, Depew, and Lancaster. Interurban lines from Buffalo to Niagara Falls and Lockport opened in 1892. The Lockport line was later extended to Olcott Beach where an amusement park and hotel were built.

In early 1901, operators of the three associated traction companies, Buffalo Traction, the Crosstown Street Railway, and the West Side Railway, realized the unprecedented problems facing them in serving the Pan American Exposition. Thomas E. Mitten, a transit operations expert from Milwaukee, Wisconsin, was recruited to become superintendent of operations.

Local streetcars served two specially constructed terminals located at opposite entrances to the exposition. The Baynes Street, Elmwood Avenue, Grant Street, and Niagara Street lines served the main, or west, terminal. Additional service was provided to the smaller east terminal opposite the Delaware Avenue entrance.

Over 101,687 visitors attended the exposition's opening on May 28, 1901. Five hundred streetcars continuously operated at the west terminal and 100 at the east terminal. During the closing-time rush, 15,000 passengers per hour boarded at the west terminal and over 5,000 at the east terminal. Handling large volumes of riders soon became routine. On September 5, a total of 477,826 riders were transported. On October 19, the total was 535,955 passengers carried. Streetcar service to the exposition was a technical and operating triumph! Before the exposition closed, local street railway officials realized the value of making these coordinated operating arrangements permanent. The result was an entirely new company formed early in 1902.

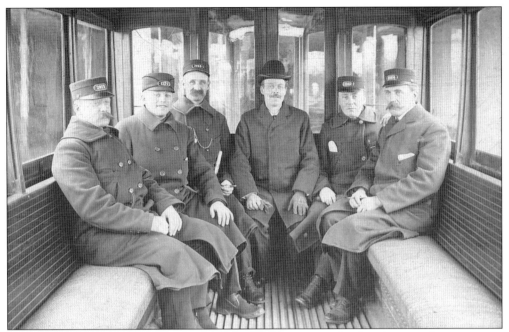

A proud group of early street railway operating employees pose for this photograph.

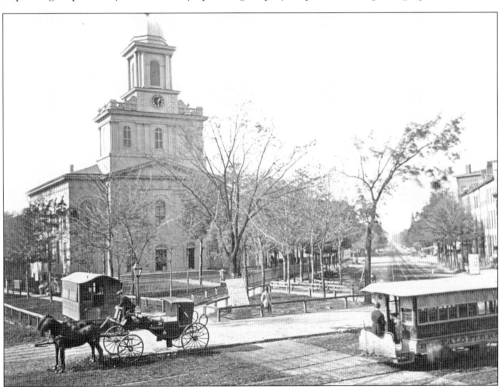

Buffalo's first horsecar line began operating on Main Street in 1860. Later that year, a second line opened on Niagara Street. Tracks of both lines are represented in this undated photograph that also features a horsecar on Main Street headed toward Cold Spring.

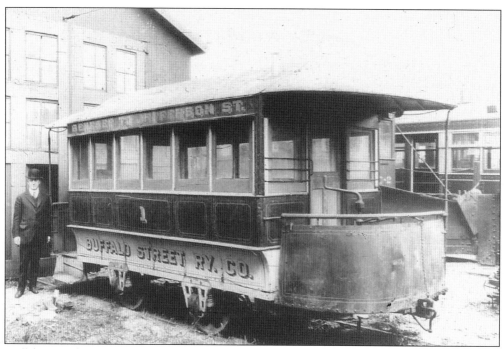

Buffalo's first horsecar was photographed at Cold Spring around 1920. Unfortunately, this car was later destroyed in a disastrous fire.

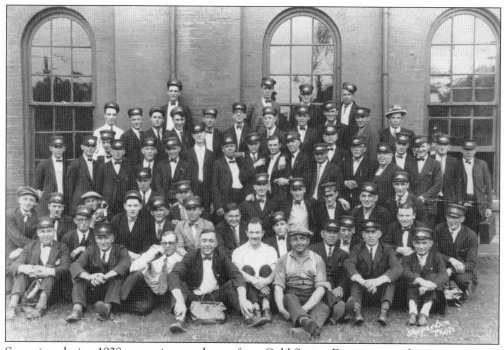

Sometime during 1928, operating employees from Cold Spring Division pose for posterity.

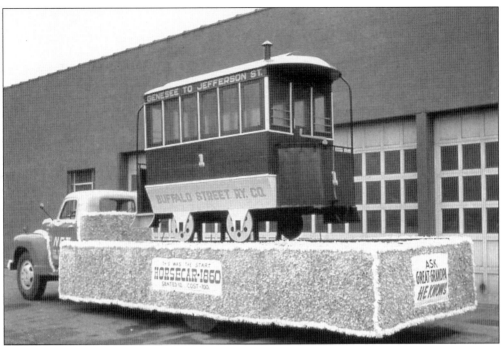

Niagara Frontier Transit (NFT) built a replica of No. 1 for display in a parade marking Buffalo's sesquicentennial in 1957. It traveled aboard NFT's 1952 GMC tire truck.

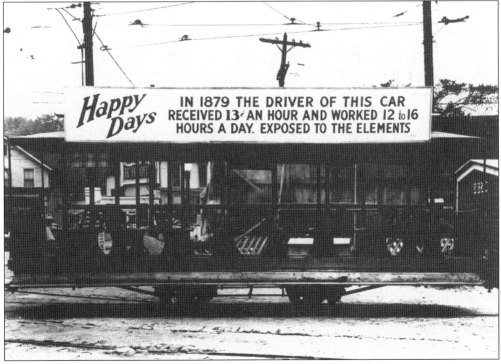

The sign on the letter board of this single-truck open horsecar tells all.

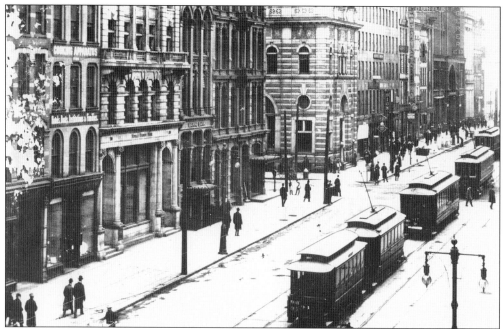

Three tracks once existed on Main Street between the Terrace and North Division Street. Two were for local cars, the other for interurbans. In this 1897 view, a motor car pulling a trailer for smokers approaches Seneca Street. Two gentlemen wearing derby hats approach the main offices of the former Buffalo Evening News. The German American Bank is across Seneca Street, and several doors north is the original Hengerer's Department Store building.

Single-truck car No. 124 pauses in front of the Connecticut Street Armory at Connecticut and Niagara Streets in 1903.

Two

THE INTERNATIONAL RAILWAY COMPANY

The International Railway Company (IRC) was organized on February 19, 1902, by its former parent International Traction Company (Traction) to acquire and operate 14 Traction-owned electric railway properties in Buffalo and the vicinity.

IRC operated 983 cars over 353 route miles of track within the following divisions: The Buffalo City Division included local lines within Buffalo and suburban lines to Depew and Lancaster, the Kenmore–Gratwick line, interurban lines to Niagara Falls, Lockport, and Olcott Beach. The Niagara Falls Division consisted of local lines in Niagara Falls, half of the two international toll bridges at Niagara Falls and Lewiston, and the interurban line to Buffalo. The Canadian Park and River Division served Chippewa, Niagara Falls and Queenston, Ontario, and the other half of the international toll bridges. The Lockport Division operated local lines in Lockport, the Buffalo–Lockport, and Lockport–Olcott interurban lines. The interurban line was leased from the Erie Railroad and also provided electric-powered freight service from North Tonawanda to Lockport.

Thomas E. Mitten served as IRC's first general manager until 1905. Improving streetcar service in downtown Buffalo was IRC's top operating priority. Before 1902, most crosstown riders reached their destinations by traveling downtown to a central terminal and transferring. IRC made this unnecessary by through routing various lines in downtown and relocating others to adjacent parallel streets. When the Fillmore Avenue–Hertel Avenue crosstown line opened in 1907, transfer junctions were established with other local lines at locations remote from downtown. Service speed and system capacity increased while congestion and operating bottlenecks were eliminated or reduced.

The original Falls Line interurban operated almost entirely on public highways. As automobile traffic increased, running times of 75 minutes for a 22-mile journey became routine.

On June 19, 1918, IRC opened the Buffalo Niagara Falls High Speed Line. By circumventing the Old Falls Line service, running times were reduced to just less than 60 minutes. Limited stop service was provided on Main Street in Buffalo from IRC's ticket office at 7 Terrace to International Junction north of Hertel Avenue. From there tracks continued to the Riverway Terminal in Niagara Falls via a largely grade separated private right-of-way.

Through service on the Old Falls Line ended in 1922. In 1926, IRC's bus-operating subsidiary, International Bus Company (IBC), began alternate Buffalo–Niagara Falls bus service on Delaware Avenue and River Road. In October 1931, the Terrace ticket office closed and the

Buffalo Niagara Falls High Speed terminal relocated adjacent to passenger steamship and main line rail terminals on nearby lower Main Street. Attempts were made to market the high-speed line as a fast connection to Niagara Falls but failed. Rail service was gradually reduced until totally displaced by buses on August 19, 1937.

The worldwide practice of front entrance and fare collection on streetcars and buses originated in Buffalo. In 1911, double-ended streetcars in Buffalo, Chicago, and Philadelphia were legally required to stop at nearside crosswalks to pick up or discharge passengers. Accidents often occurred when conductors, stationed on the rear platform inside the car, would signal the motorman to proceed just as previously unseen passengers rushed to board. Other accidents occurred when passengers alighted from the rear platform and stepped into the path of oncoming vehicles.

Out of this situation was born the single-end Nearside car. While stopped at nearside crosswalks, all passengers boarded and alighted at the front platform under watchful eyes of motorman and conductor. Exiting passengers had clear views of opposing and parallel traffic. Additional exits at the rear of the car were available to speed unloading at major terminals or for emergency use.

Exclusive use of the front platform allowed more equal division of employee responsibilities. Motormen controlled entrance and exit doors and were solely responsible for all car movements. Conductors collected fares and issued and received transfers. Both performed their duties from a seated position inside a warm and comfortable streetcar. Improved passenger amenities included large illuminated destination and route number signs, improved interior lighting, heating, ventilation, seating, and wider aisles than in older cars.

Nearside cars began revenue operation on September 17, 1911, on IRC's Grant Street line in Buffalo. Passenger accidents immediately decreased. Requiring inbound passengers to pay as they entered and outbound riders to pay as they exited increased operating efficiency by reducing dwell times and terminal delays. The Nearside car was designed by IRC superintendent of equipment Ralph T. Senter while working under Mitten's supervision. New car prices included a five percent fee paid to Mitten for consideration in designing and supervising construction. In 1911 and 1912, Traction acquired 387 single- and double-truck Nearside cars, and then resold them to IRC under an extended payment arrangement at five percent annual interest. This arrangement exemplified the relationship between IRC and Traction. IRC capital stock was pledged to Traction, which in turn pledged it as collateral for Traction's own collateral trust bonds. IRC also assumed all liabilities of former Associated Traction properties.

Local ownership of IRC ended in 1905 when Nelson Robinson, a New York City investment banker, and associates acquired voting control of Traction. Mitten departed that same year but remained associated with Robinson until his untimely death in October 1929.

Between 1902 and 1910, IRC paid over $5 million in dividends, yet during the same time, was deprived of funds for capital improvements, which had to be financed through loans from the parent company.

In 1910, IRC had to pay for 200 previously acquired streetcars. Dividend payments were omitted, which caused Traction to default. By 1912, IRC and Traction were deeply in debt. Refinancing was obtained, but management control was turned over to an outside firm associated with Robinson. The firm failed to perform. In 1918, IRC and Traction again defaulted. Robinson formed a committee to secure the bonds. In 1920, this committee took control of IRC and hired a new president to act under its direction.

In 1921, IRC faced pressure from striking employees and jitney operators. Although possessing a competent staff, Robinson was anxious to protect his investment and executed a management contract with Mitten Management, a firm created by Mitten and financed by Robinson. This outside supervision endured until 1943, when the New York State Public Service Commission (PSC) ordered it terminated because they felt it was unnecessary and deemed Mitten's financial management discreditable.

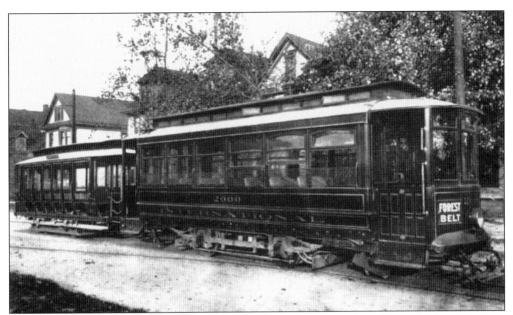

Independent street railway operators had distinctly different philosophies regarding streetcar design. The West Side Railway operated over many narrow, congested west side streets, and thus preferred large single-truck cars. Frequently two-car trains were operated, but many times the second car was used to accommodate passengers who smoked.

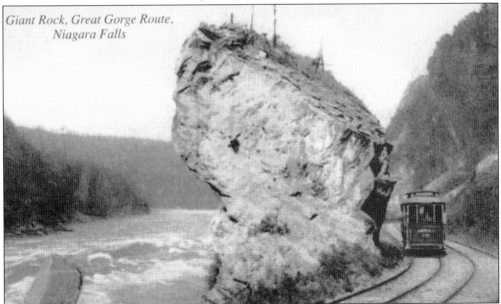

Giant Rock, Great Gorge Route, Niagara Falls

The *international* in IRC's corporate name was derived from its two international toll bridges, the Fallsview Bridge located at Niagara Falls and the Lewiston-Queenston Bridge about seven miles downriver. Both carried pedestrians, streetcars, and other vehicular traffic. The Great Gorge Route provided passengers with spectacular views of the lower Niagara River on both sides of the gorge. A huge rockslide on September 17, 1935, ended operation. A massive ice jam in 1938 collapsed the Fallsview Bridge. IRC sold all related assets to the Niagara Parks Commission. Today's Rainbow Bridge serves as a replacement.

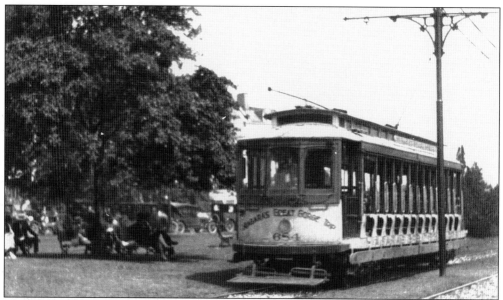

Great Gorge Route trolley sightseeing tours began at the Gorge Terminal in Niagara Falls, New York. Streetcars entered Canada at the Fallsview Bridge and proceeded upriver to Chippewa, and then reversed directions and traveled along the Niagara River Parkway to the Queenston Bridge and reentered the United States. Cars descended into the gorge and ran alongside the Niagara River until north of downtown and then resumed street running before returning to the Gorge Terminal. Open car No. 684 travels along the Niagara River Parkway in Niagara Falls, Canada. Gorge Route Canadian operations ended on September 11, 1932, but service continued on the United States side until a massive rockslide shortly before the end of the 1935 summer season ended operations forever.

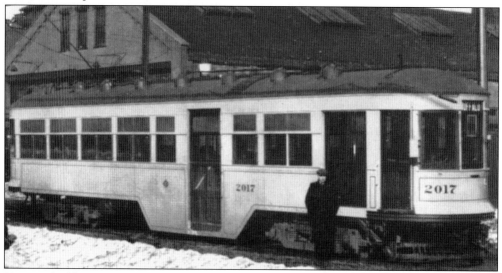

Twenty double-end center-entrance interurban cars, No. 2000–2019, were built for Buffalo Niagara Falls High Speed Line service in 1918. They were capable of operating speeds exceeding 60 miles per hour and frequently ran in two- or three-car trains. They were painted a bright yellow with gray roofs, red doors, and black striping. Although high-speed service ended in August 1937, many cars languished at Cold Spring until after World War II before being scrapped.

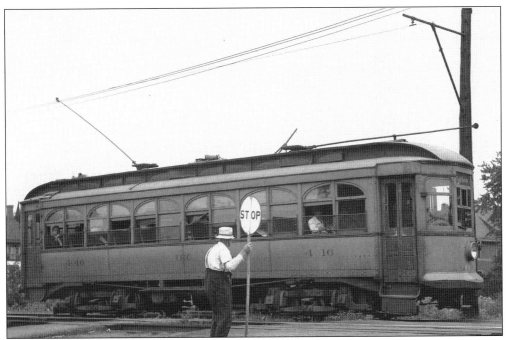

A crossing guard protects the Goundry Street crossing of the Buffalo–Lockport–Olcott interurban lines several days before service ended in August 1937.

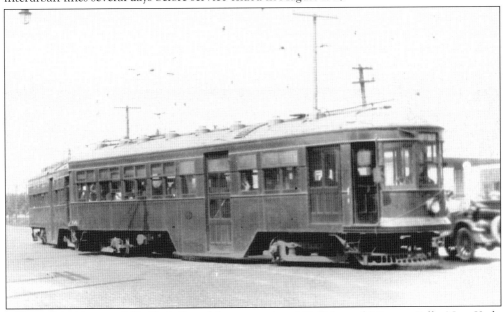

The Buffalo Niagara Falls High Speed Line connected Buffalo and Niagara Falls, New York, the Tonawandas, and other smaller on-line communities. It also competed with various steam railroads for the Niagara Falls tour business. It met arriving passengers from steamships and main line rail terminals on lower Main Street in Buffalo and transported them to Niagara Falls, New York, where connections were available to IRC's Great Gorge Route for Niagara Falls tours or to Youngstown for boats to Toronto. In the mid-1920s, this two-car Buffalo-bound high-speed line train approaches the village of LaSalle.

This photograph shows the IRC Gatwick trestle of the original Buffalo–Niagara Falls line that crossed the high-speed line near North Tonawanda. Notice the cat in the station window.

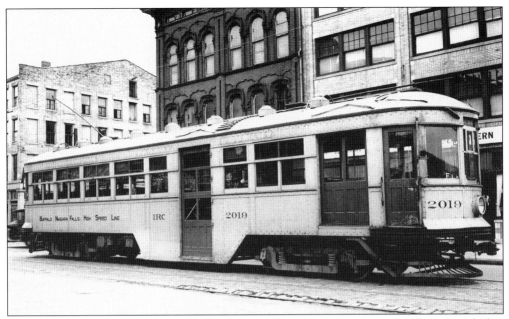

On September 19, 1934, the crew of Buffalo Niagara Falls High Speed car No. 2019 relaxes before departure from Buffalo.

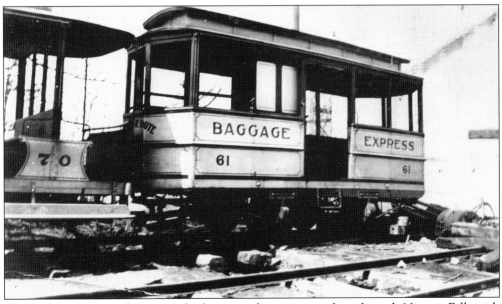

This little car was used to carry the baggage of tourists traveling through Niagara Falls with stopovers to ride the Great Gorge Route.

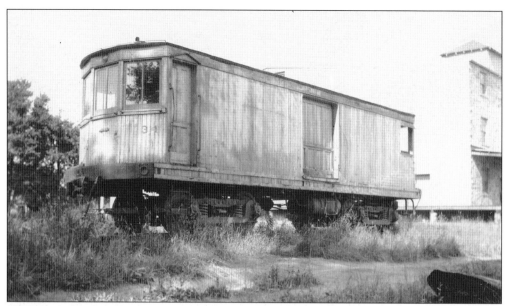

This former IRC freight motor was sold to the Lewiston and Youngstown Frontier railroad in the late 1930s.

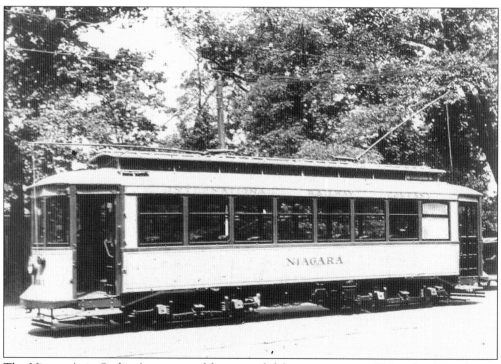

The *Niagara* (née *Ondiara*) was one of five named deluxe private cars IRC utilized for charter service. It is shown here after being rebuilt in 1930. In August 1927, all five private cars transported the prince of Wales and other important guests from Buffalo to Niagara Falls for a trip over the Great Gorge Route.

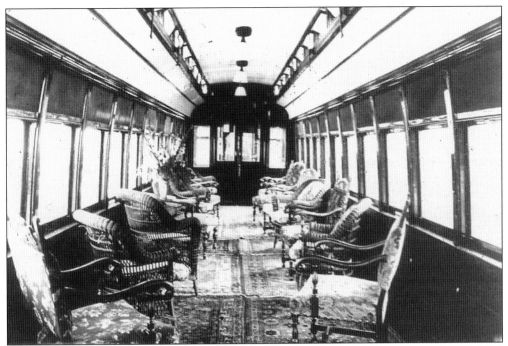

Inside the *Niagara*, note the fine woodwork, ornate brass fixtures, deluxe woven carpeting, and upholstered wicker seats. After the *Niagara* was retired, these seats were used in the lobby of the mechanical department well into the 1970s.

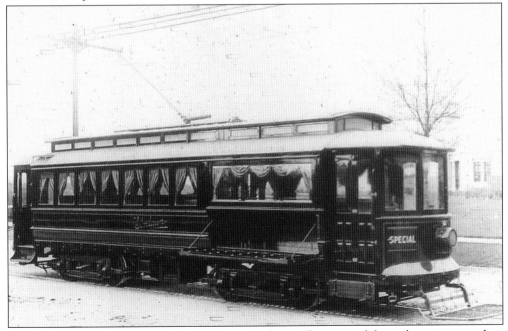

IRC owned two funeral cars, *Elmlawn* and *Greenlawn*. They carried funeral parties to on-line cemeteries. Deceased and mourners rode in a separate front compartment. Invited guests rode in the rear. This photograph was taken outside the entrance to the Forest Lawn Cemetery at Delaware and Delavan Avenues.

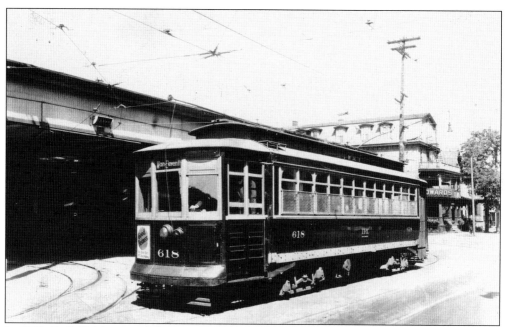

In 1930, G. C. Kuhlman and Company of Cleveland, Ohio, rebuilt and enclosed many 600-series open cars. Afterward they were assigned to light-duty service in Buffalo, Lockport, and Niagara Falls. Car No. 618 poses at the IRC car house on Main and Eleventh Streets in Niagara Falls in 1930. The last 600s were retired in 1938.

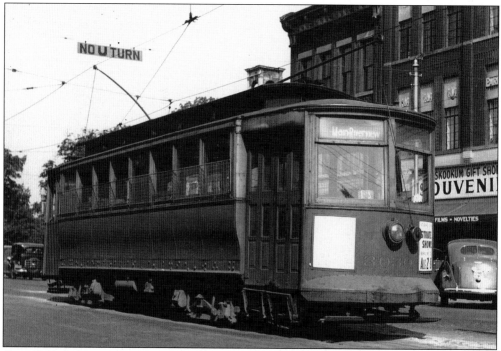

Cars 3000–3049 were purchased in 1903. Some were powered, others were trailers. All were rebuilt several times before retirement in 1937. They were normally used on light-duty lines on Buffalo's west side and in Niagara Falls, as seen here.

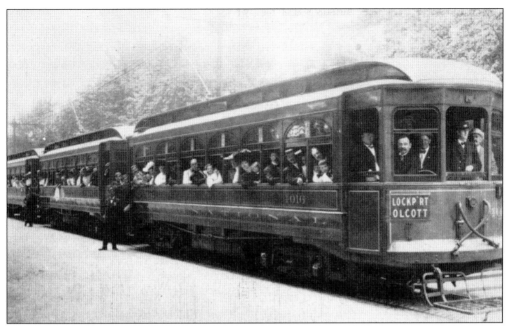

Philadelphia streetcar builder J. G. Brill and Company built interurban cars 4000–4035 in 1904. Some were powered, others were trailers. They operated on the original Niagara Falls line and also the interurban to Lockport and Olcott Beach. They were converted to one-man operation in 1929. When the service to Lockport and Olcott ended in 1937, all were retired. This three-car train is shown at the Olcott station.

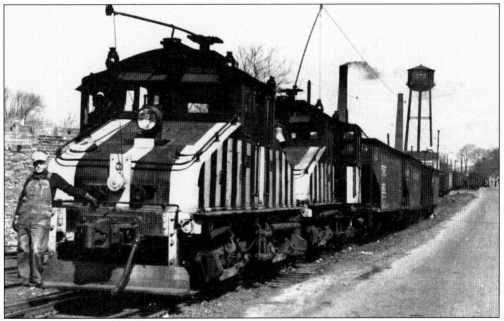

IRC provided electric freight service between North Tonawanda and Lockport over a line leased from the Erie Railroad. Locomotives P-1 and P-2 were among the earliest examples of General Electric's steeple cab type of electric switching locomotives. In this 1940 view, they switch cars in Lockport. Electric freight service ended in December 1950.

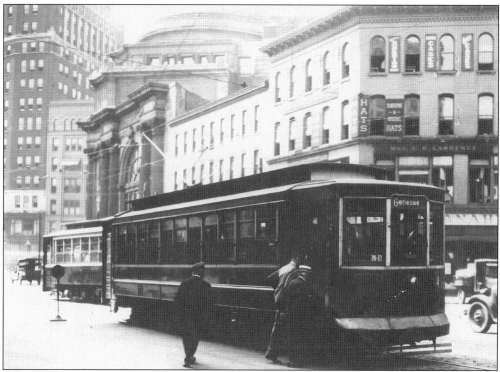

PAYE (pay as you enter) cars 5000–5199 arrived in 1908. They were remodeled for one-man service in the 1920s. Two rebuilt cars meet at Genesee and Washington Streets.

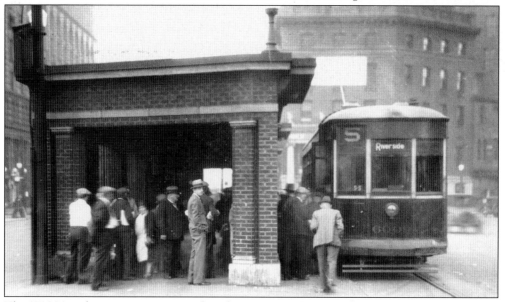

The 370 Nearside-type streetcars, numbered 6000–6370, dominated IRC service in Buffalo from 1911 until 1935. Their front entrance and exit made them ideally suited to one-man operation. In this 1930 view, No. 6009, the ninth car built in the original order of 1911, prepares to depart from Shelton Square for a trip on the Niagara Street line. This car was among the final group of 50 Nearsides that remained active until 1950.

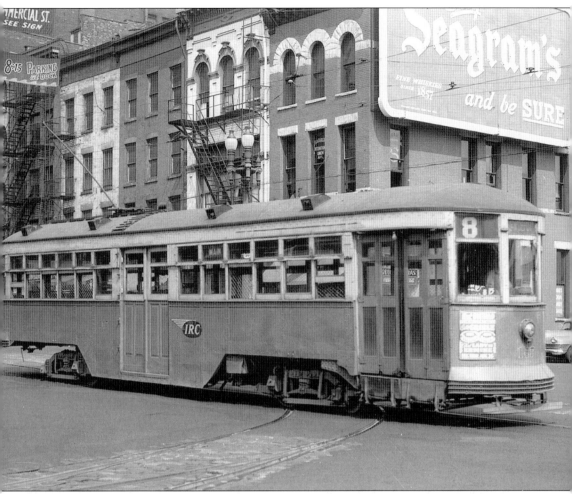

The major weakness of Nearside cars was inadequate passenger circulation within the car, which caused crowding on the front platform and slowed service. The 130 Peter Witt streetcars, Nos. 100–229 built by G. C. Kuhlman in 1917 and 1918, solved this problem by placing the conductor just in front of the center doors. Passengers boarded at the front and were induced to move to the rear of the car where they paid the conductor who was stationed just before the center doors. All passengers exited through the center doors. Peter Witt cars operated exclusively in the Buffalo Division, and most remained active until streetcar service ended in 1950.

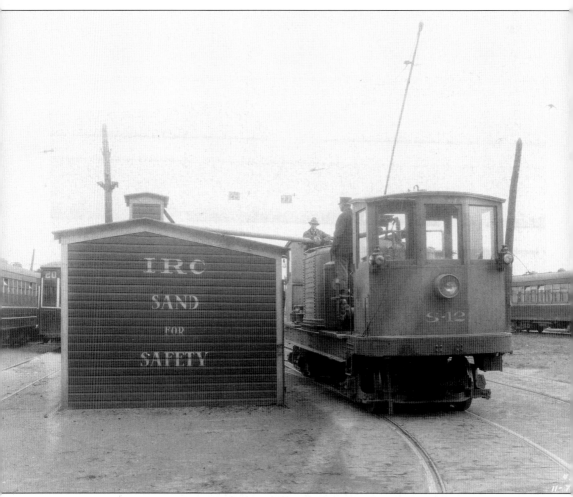

IRC designed and built this special car in 1929 to transport sand from each carbarn to sandboxes located at the outer terminals of each streetcar line. The motorman could obtain sand to use in sandboxes of individual streetcars to obtain traction on slippery or icy rails. The power trucks under this car were originally used in the funeral car *Elmlawn*.

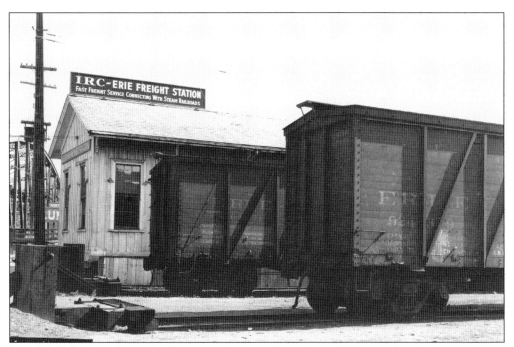

An interchange yard and small freight depot used jointly by IRC and the Erie Railroad was located near Payne and Erie Avenues in North Tonawanda.

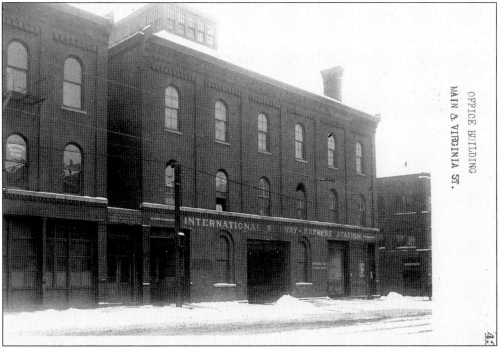

IRC's package freight station at 885 Main Street at Virginia Street in the heart of Buffalo was constructed in 1878 as a horsecar barn. Later the overhead line department used it, and for a time, it also served as the garage for IRC's bus-operating subsidiary, IBC. It later served as NFT corporate headquarters from 1950 until 1976. It was destroyed by fire in 1978.

This mid-1920s view shows the train room where operating crews reported for work. Offerman Stadium, home to the Buffalo Bisons baseball team until 1963, appears in the background.

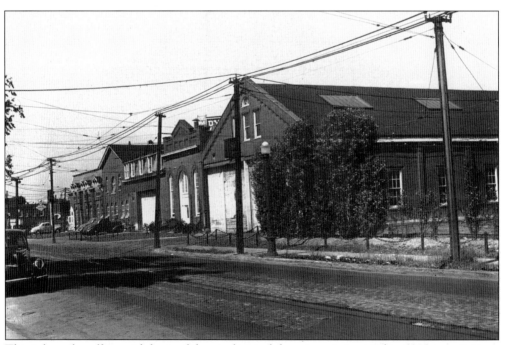

This is how the offices and shops of the mechanical department appeared in 1945.

This early-1920s interior view is of the train room at Cold Spring.

This transfer table at Cold Spring was used to move inoperable streetcars from storage yards to the unit change shop. Note the streetcar control cabinet and overhead trolley wire.

Forest Paint and Carpenter Shop
Photo by Palmer - 7/3/45

Fire destroyed the Cold Spring paint shop in 1929. In 1931, the Forest Division closed and its routes were transferred to the Hertel Division. After 1931, the building served as the bus body repair and paint shop. Later it housed Teck Garage. Today it is owned by the Buffalo and Erie County Historical Society.

Three International service trucks were purchased in 1930. Two were overhead line trucks; the third was fitted with a platform body used for hauling materials and supplies.

Three

HERE COMES THE BUS

On August 15, 1923, IRC formed a bus-operating subsidiary, IBC, to carry passengers within Buffalo and between Buffalo and Niagara Falls and intervening points. On September 7, 1923, several used buses, obtained from a Mitten-affiliated equipment dealer in York, Pennsylvania, began Bailey Avenue service between Winspear Avenue and Broadway. Buses were garaged at Main and Virginia Streets but were driven by operators from the Forest Division.

During the 1920s, double-deck buses were briefly popular in some cities where enough attractions existed to create a single-seat bus ride long enough to entice passengers to ride upstairs. Buffalo's Delaware Avenue was such a thoroughfare. On November 2, 1924, ten open-top double-deck buses opened IBC's second route, Delaware Avenue. Service began at the Terrace and ended at the Albright Art Gallery. Fares were 10¢. Transfers to IRC streetcar lines were free, but since carfare was 7¢, transferring from IRC to IBC cost 3¢.

Meanwhile, a Mitten Management Company review of its bus operations in Buffalo and Philadelphia revealed the average lifespan of a bus was five years. Ways to lengthen service life were sought. The result was the gas-electric bus, created in conjunction with the General Electric Corporation and the Yellow Coach bus-manufacturing division of General Motors.

Operating principles of gas-electric buses are simple. The engine is connected to an electric generator providing current to motors that propel the rear wheels. Conventional rough shifting, noisy transmissions, wear and tear on bus and operator, gear grinding, jerky shifts, and time consumed changing gears while operating in congested traffic were eliminated and replaced by smooth, quiet electric drive.

On November 8, 1924, IBC ordered 16 semienclosed gas-electric double-deck buses for Delaware Avenue and Bailey Avenue routes and 12 single-deck gas-electrics for a third route on Delavan Avenue. As the number of coaches needed to provide service increased, bus operations were transferred to the Walden Garage on January 10, 1925. The following day, Delavan Avenue service from Niagara Street to Bailey Avenue began.

In 1926, a group of deluxe coaches based at the Walden Garage began Buffalo–Niagara Falls interurban service. They were also used for charters and regional Gray Line sightseeing tours. When the Peace Bridge opened in August 1927, these buses began service to Fort Erie, Ontario, and the Fort Erie Racetrack. Others ran in pool service with Mitten-affiliate Philadelphia Rural Transit Company on multiday overnight excursions from Philadelphia to Niagara Falls with stopovers in Buffalo.

Later in 1927, sixty-five new single-deck gas-electrics entered service on the Bailey Avenue, Delaware Avenue, and Delavan Avenue routes.

On August 9, 1928, a new streetcar loop at Kenmore Avenue and Virgil Street opened and suburban streetcar service to Tonawanda ended. On October 11, remodeled one-man double-deck

buses providing peak-period express service on Delaware Avenue from downtown to the city of Tonawanda replaced the former suburban streetcar service.

Bailey Avenue–Cleveland Hill bus service via Kensington Avenue to Hanley Road began on January 25, 1929. On June 22, shortly before the new New York City terminal in East Buffalo opened, IBC began the Central Terminal express bus service to downtown and hotels.

On January 1, 1931, IRC's first bus route in Niagara Falls began operating on Hyde Park Boulevard. In Kenmore a new route on Colvin Boulevard from Stillwell Avenue to the Virgil loop began on January 11. IRC suburban streetcar service to Depew and Lancaster ended on August 22. An existing parallel competing bus route operated by Buffalo Transit took over the following day. The Walden Garage closed on November 8, and bus operations were distributed among Cold Spring, Hertel, and Broadway Garages.

Despite the patronage decline of the Great Depression, in 1931 IRC's 789 streetcars and 83 buses provided 211 miles of coordinated service. IRC safely and economically carried 110 million passengers. This equaled 192 per capita riders per year and 301,000 daily riders. Fifty-eight percent of all people traveling in and out of downtown Buffalo rode IRC streetcars and IBC buses, yet these same vehicles represented fewer than four percent of all vehicles on the streets. This was fitting testimony to the combined abilities of IBC and IRC to move people efficiently.

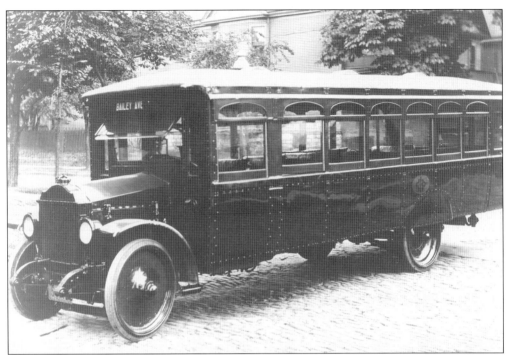

IBC's first bus is believed to have been built on an Atlas truck chassis fitted with a Brill-built body. This bus carries 1923 Pennsylvania dealer's license tags, thus providing credence to the story that IBC's first buses were obtained from a Mitten-affiliated Atlas truck dealer in York, Pennsylvania.

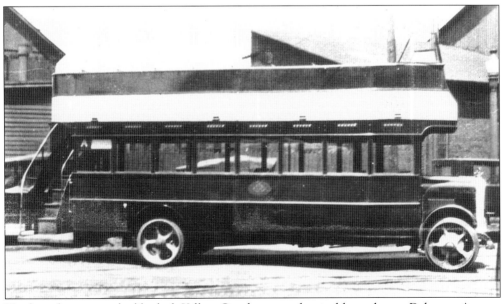

Ten leased open-top double-deck Yellow Coach gas-mechanical buses began Delaware Avenue service in November 1924. Yellow Coach gas-electrics replaced them the following year.

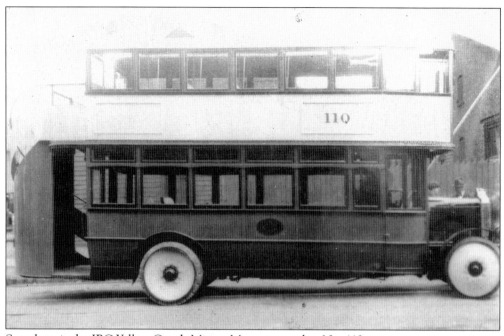

Seen here is the IBC Yellow Coach Mitten Management bus No. 110.

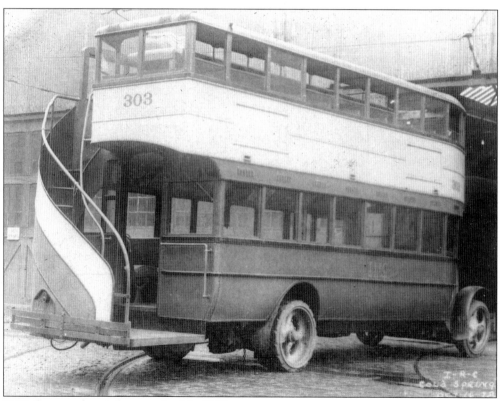

IBC's first gas-electric buses arrived in 1925.

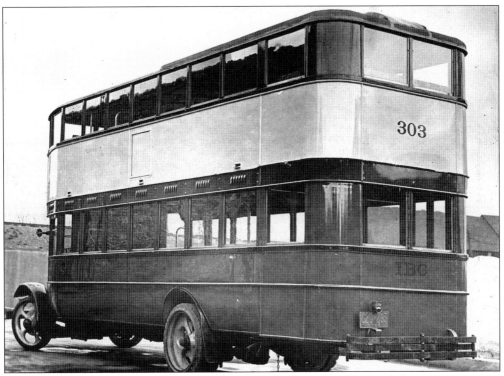

In 1928, IBC remodeled the sky parlors for one-man operation. Upper decks and connecting stairways were fully enclosed. Downstairs a front entrance/exit door was installed, and to the rear a separate door for emergency use was added.

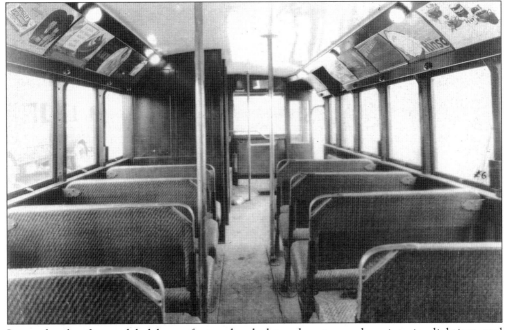

Lower levels of remodeled buses featured upholstered seats, modern interior lighting, and large-capacity heaters.

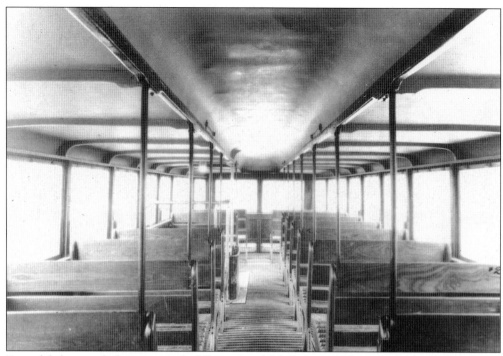

Remodeled upper decks were simply fully enclosed. No lighting or heat were provided.

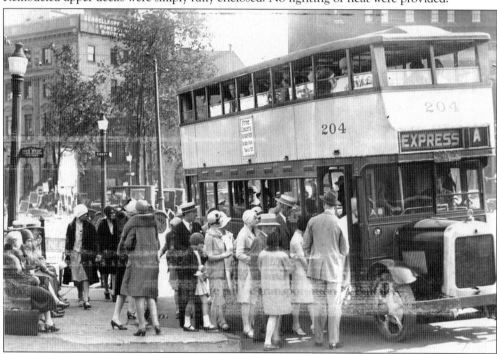

After 1928, rebuilt double-deck buses provided peak-hour express service on Delaware Avenue from downtown to Kenton Avenue in Kenmore. During 1933 and 1934, several transported construction workers to the new state prison in Attica. All double-deckers were retired on June 15, 1936.

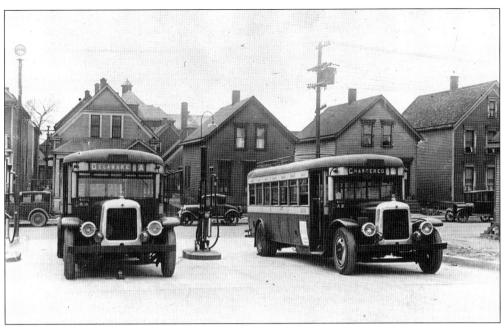

Two 500-series Yellow Coach type Z 32-passenger gas-electric transit buses stand at the fuel island at the Walden Garage and Lathrop Street sometime in 1928.

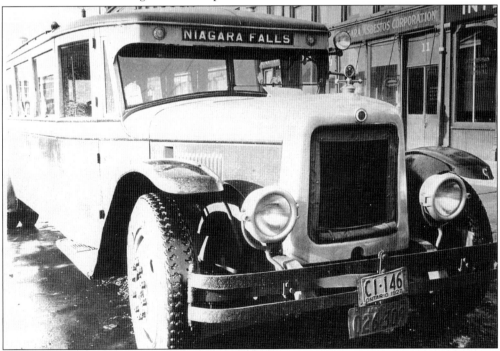

The 400-series Yellow Coach chair cars were deluxe 25-passenger buses delivered in 1926 for interurban service to Fort Erie and Niagara Falls, Canada. When IBC became a Gray Line affiliate, 400s operated on regional sightseeing tours. Others ran in pool service with Mitten-affiliated Philadelphia Rural Transit on multiday excursions between Philadelphia and Niagara Falls with stopovers in Buffalo.

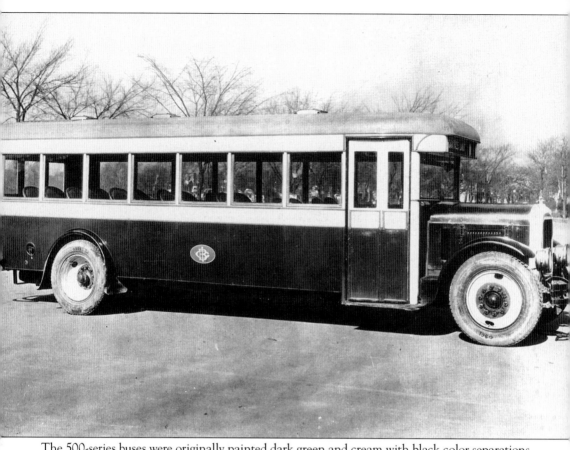

The 500-series buses were originally painted dark green and cream with black color separations.

Gas-electrics proved long lasting and durable. Most remained active until the late 1940s. After retirement they were sold to a salvage yard located on Ridge Lea Road in the town of Amherst where they remained until the yard was cleared during the early 1960s to make way for the Youngman Highway (I-290). One is rumored to exist somewhere in Alabama.

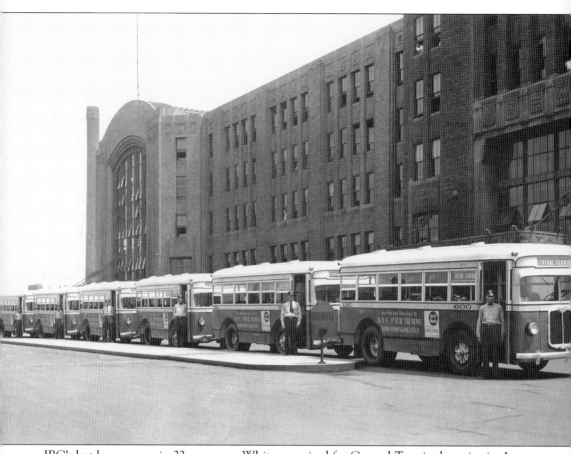

IBC's last buses were six 22-passenger Whites acquired for Central Terminal service in August 1934. After 1936, some were used on the Summer Street–Best Street bus route. All were retired prior to World War II.

Four

FROM RAILS TO RUBBER

Streetcars made downtown development possible; yet by 1932, the system had become susceptible to change and required substantial physical improvements. IRC's survival depended on its ability to meet these changing conditions. Recent bus experience and a sincere desire to improve service resulted in preparation of "the Comprehensive Plan for Transit Improvement" of June 17, 1932. Existing transit facilities were examined and specific recommendations, based on prevailing circumstances, made for improving IRC and IBC services, including constructing a new double-track streetcar terminal in Lafayette Square bringing east and south side streetcar lines closer to lines serving the west side; rerouting Clinton Street and William Street cars from Ellicott Street to Washington Street; extending Kensington Avenue streetcar service on Main Street from Huron to Court Streets; substituting buses for streetcars on the Michigan Avenue–Forest Avenue route providing improved service to State and Millard Fillmore Hospitals and Forest Lawn areas; removing streetcar track on Delaware Avenue between Delavan and Forest Avenues so the street could be widened; replacing the Hoyt car line with a new Baynes Street–Richmond Avenue bus route to redistribute service between Elmwood Avenue and Grant Street lines and eliminate rail operation on narrow west side streets; replacing Connecticut and Best Streets streetcars with a new bus route on Porter Avenue from Niagara Street to Humboldt Parkway; replacing West Utica Street streetcars with buses and extending service to Swan Street to provide improved connections with lines at Shelton Square; extending Colvin Boulevard bus service to Amherst Street and Delaware Avenue to downtown; beginning new Ontario Street bus service from the city line to Tonawanda Street; and adding new Kenmore Avenue bus service from Main Street/ Bailey Avenue to Niagara Street.

IRC studies indicated 75 percent of annual system mileage operated during off-peak periods. Further study revealed 25-passenger buses could provide the same headway as the streetcars they replaced but with obviously lower operating costs and still retain existing riders. These cost savings could be used to provide increased service frequency without additional expenditures.

On January 16, 1935, the New York Public Service Commission approved bus substitutions of the Comprehensive Plan. On March 20, 1935, forty-eight Mack 25-passenger CW medium-duty transit-type buses were ordered to begin bus conversions. On June 1, 1935, IBC merged with IRC. What began as a single route in 1923 evolved into a fully integrated seven-route network with 92 buses transporting almost 10 million annual riders.

Operations of the Niagara Gray Bus Line from Niagara Falls to Lewiston, Youngstown, and Fort Niagara were acquired and merged into the IRC system on June 16, 1936.

All recommended bus service improvements of the Comprehensive Plan were implemented by 1937. By 1939, rail services outside Buffalo were converted to bus operation or abandoned. IRC operated 262 streetcars and 436 buses, with 370 purchased since 1935. Buffalo led all cities of

its size in bus substitution. More than 90 percent of city residents lived within a quarter mile of 27 IRC local bus or streetcar services, 21 of which served downtown. Six crosstown routes provided convenient connections. Service miles increased as passengers discovered the quick, frequent, and reliable bus service. Public relations constantly improved. IRC was proud of its new image.

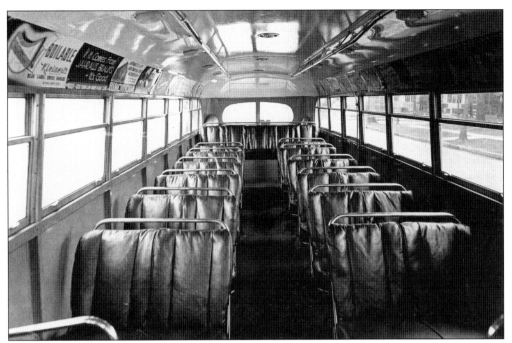

When passengers boarded any one of IRC's 370 Mack CW buses they were immediately greeted by luxurious contoured leather seating for 25.

Forty-eight Mack gas-mechanical CW buses, Nos. 700–747, were purchased in 1935 to convert several lightly patronized west side streetcar lines that operated over narrow congested streets. The Ontario route was short lived and was later combined with the Kenmore Avenue crosstown service.

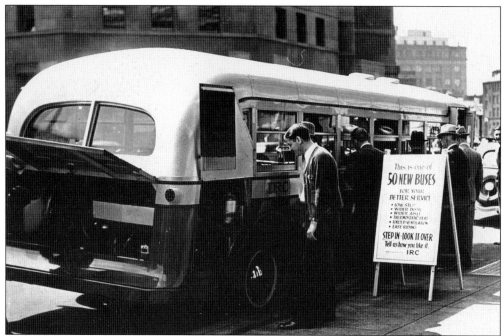

This bus was placed on public display just outside of Niagara Square.

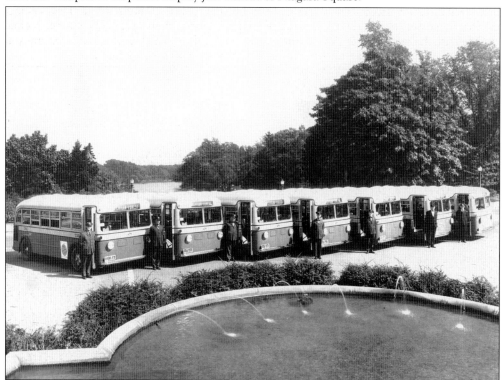

Seven proud motor coach operators and seven sparkling new olive green, cream, and silver Mack buses pose behind the Albright Art Gallery in September 1935, shortly before entering service on the West Utica Street and Michigan Avenue–Forest Avenue lines.

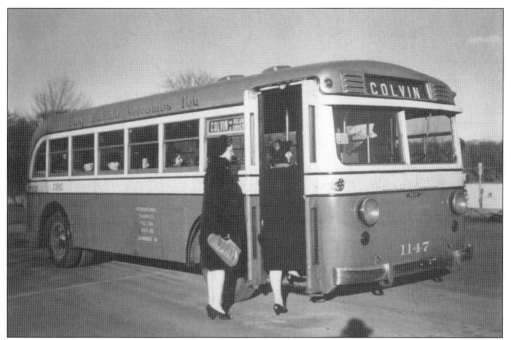

Between 1935 and 1939, IRC purchased 370 Mack CW buses, including five gas-electrics. The first Mack diesels replaced 269 coaches in 1949. The remaining 100 units ran until the summer of 1953. Some were sold to Kenmore-based Wooley Bus Lines, others were converted into mobile civil defense shelters, but many more were simply banished to local wrecking yards. Several still survive today. This bus was photographed in late 1939 at Delaware Park Lake.

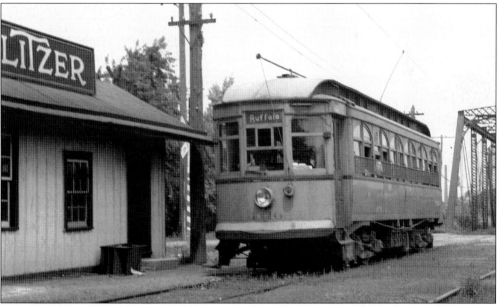

Scenes like this faded forever when Route B Buffalo–Lockport–Olcott Beach interurban service ended in August 1937. A Buffalo-bound car has just crossed Niagara Falls Boulevard at Erie Avenue and nears the station stop at Wurlitzer used almost exclusively by employees of the world-famous manufacturer of theater organs and jukeboxes.

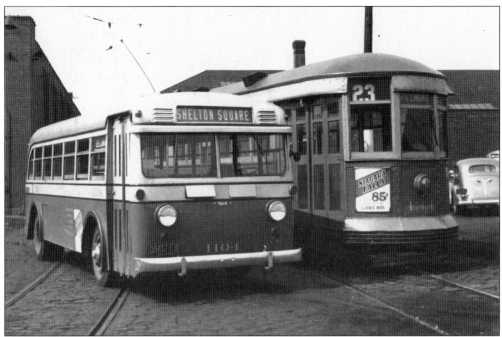

A 1939 Mack bus and an IRC Peter Witt–type streetcar built in 1917 are seen at Cold Spring Division.

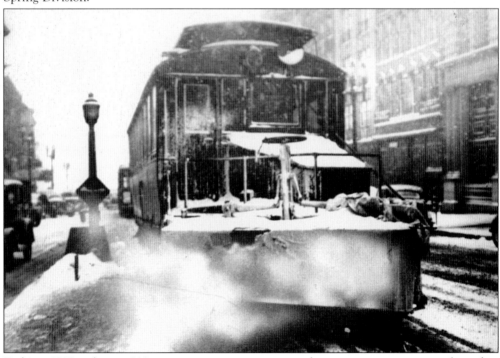

Early in 1937, a former 800-series passenger car converted to a snow sweeper is outbound at Main and Seneca Streets. The sweeper itself was a rotating drum fitted with bamboo bristles that effectively removed light to medium snowfalls and anything else that happened to be on the track, including glass bottles and hardware.

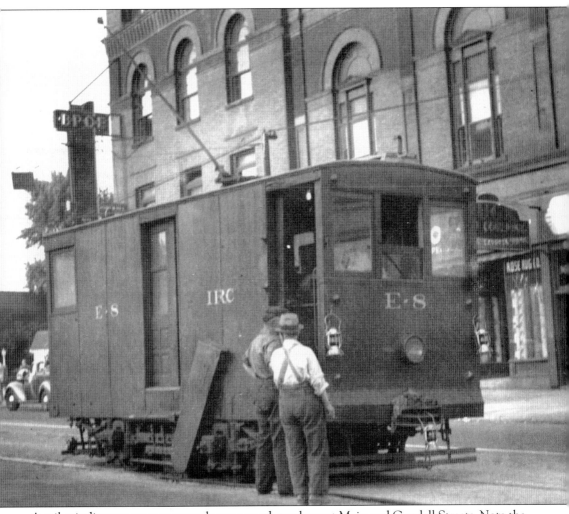

A rail-grinding car stops to smooth some rough trackage at Main and Goodell Streets. Note the lanterns on the side of the car.

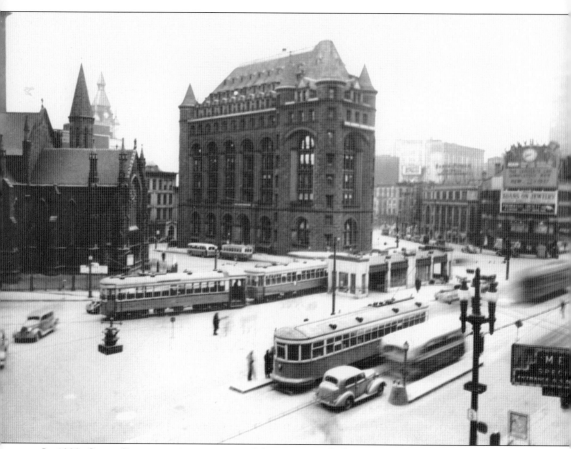

In 1939, Grant Street streetcars competed for space in Shelton Square with many IRC buses. By year's end, they were gone.

Five

INTERNATIONAL RAILWAY COMPANY, SOLDIER OF TRANSPORTATION

In September 1940, the City of Buffalo and IRC negotiated a long-term plan for continued modernization of local transit services. IRC agreed to seek permission for replacing streetcars with buses by October 1, 1950. Otherwise permission to continue specific streetcar services could be granted in yearly increments on a route-by-route basis. During summer months, buses substituted for streetcars weekday evenings, Sundays, and holidays. Lastly, IRC was required to remove up to eight miles of abandoned streetcar rail annually and repave affected streets at its own expense.

IRC immediately sought permission to convert the Jefferson Avenue, Seneca Street, South Park Avenue, and William Street lines to permanent bus operation. This was accomplished by September 28, 1941.

Anticipating heavy transportation needs of defense industries and military bases, IRC ordered 200 Mack buses in mid-1941. Delivery was completed in March 1942. IRC now owned 636 coaches, including 570 Macks.

On December 19, 1942, IRC carried 765,880 passengers, the busiest day in its entire history. In 1943, IRC carried 217 million passengers, 400 percent greater than in the Depression. More people rode IRC services in Buffalo than in any other American city of comparable size except Washington, D.C. Increased rush-hour riding taxed manpower and equipment to maximum limits. Harsh winters strained carrying capacity. IRC employed 2,300 workers, but many were lost to wartime service elsewhere. Replacements were recruited through a vigorous campaign of advertisements placed on buses and streetcars, in newspapers, and on the radio. IRC hired its first group of woman employees on September 21, 1942. The first African Americans were hired on October 11. Both groups performed admirably and were well received by the public. Many stayed on after the war until retirement.

Wartime employment at the 218 defense plants in the Buffalo–Niagara Falls region rose from 120,000 in 1941 to 214,000 by 1943. Service extensions were made to defense industries such as Bell Aircraft, Chevrolet, and Curtiss-Wright assembly plants. Bailey Avenue bus service was extended to meet streetcars at Main Street and the city line. Service was added to war

industries located on the Jefferson Avenue, Seneca Street, and South Park Avenue routes. Other routes received extended evening service. Thirteen bus routes were combined to better serve shift workers.

In Niagara Falls, new bus service began on Pierce Avenue and to the Lake Ontario Ordnance Plant. The Niagara Street route was extended to the city line, three combination routes were created, and a more direct route was implemented for transporting military personnel between Buffalo and Fort Niagara.

A limited number of vehicles were available to handle increased use of public transportation mandated by wartime conditions. IRC felt this would diminish the appeal of its services, so it began a massive campaign of newspaper and radio advertising to keep people informed about the problems of providing wartime transportation and to enlist their assistance in making the most efficient use of available facilities. In many newspapers, advertisers depicted how IRC buses and streetcars served their facilities.

Before the war and during, relations between IRC and its employees were conducted in mutual respect. Many workers had been employed for a short time while others had been continuously employed for many years. Continued cooperation by all got the work done. Of 200 woman employees, 92 were bus operators. Others performed mechanical inspections and servicing. Extensive use was also made of part-time employees from outside IRC or IRC employees from nonoperating departments. Riding was so heavy, vacation relief was impossible. Through collective bargaining, the Frontier Bus and Street Car Employees Union agreed to waive vacations and IRC agreed to pay the usual vacation allowances in addition to the earned pay.

A 1940 view of Main Street, looking north from Shelton Square, features the Erie County Savings Bank, several retail and dining establishments, the former Lee's Harvey and Carey drugstore, and other prominent downtown buildings.

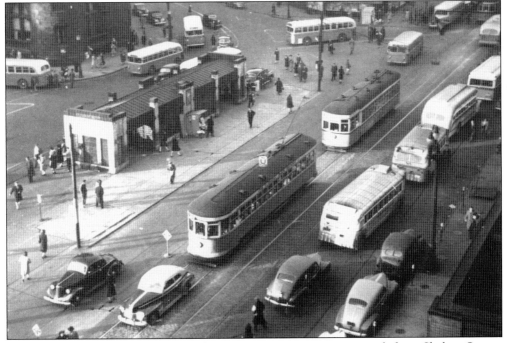

A 1938 Plymouth, a 1941 Pontiac, and two IRC streetcars await a green light at Shelton Square while several northbound Buffalo Transit buses pass the Palace Burlesk Theater.

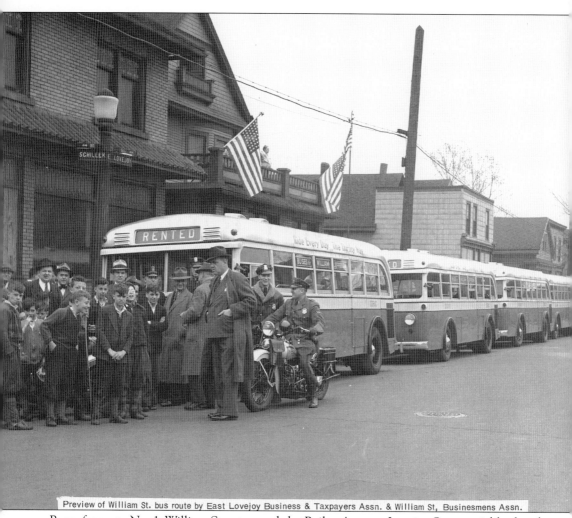

Preview of William St. bus route by East Lovejoy Business & Taxpayers Assn. & William St, Businesmens Assn.

Buses for route No. 1–William Street served the Bailey Avenue–Lovejoy Street neighborhood. In April 1941, members of the Bailey-Lovejoy Business Association welcome the replacement service.

Six

A BUMPY RIDE

Postwar patronage remained at record levels. Continued operation of certain buses and streetcars scheduled for retirement in 1942 was required. Streetcars received essential body and mechanical repairs, but many buses remained out of service indefinitely as necessary parts and labor to repair them were not always available. A bus shortage developed and overcrowding occurred. Concern was so great, a temporary authority, the Niagara Frontier Transit Commission, was created by the state legislature to determine adequacy of local transportation and recommend improvements. The commission suggested creating a public authority to acquire operations of 14 local carriers, including IRC, and operate them as a two-county unified system. A bill to this effect was introduced in the legislature but failed to pass.

On April 10, 1945, IRC ordered 50 Mack C-41 transit buses. Deliveries were delayed until January 1947 due to restrictions on parts and materials, a lengthy strike by Mack production workers, and a huge backlog of orders for new buses. When the buses arrived, IRC utilized every available advertising method to inform passengers of their arrival. Broad media coverage was provided, and buses were assigned to routes throughout the system so the greatest number of people could enjoy their comfort and convenience. Their arrival permitted conversion of the East Utica Street streetcar line to permanent bus operation on February 16.

For additional coaches, IRC sampled the completely redesigned and locally built postwar Twin Coach. A total of 171 model 41-S coaches were acquired in 1947 and 1948.

The 221 new postwar buses replaced remaining gas-electrics and secondhand buses acquired in 1946. Their high seating capacity alleviated many customer complaints about overcrowding. On February 22, 1948, buses replaced streetcars on the Clinton Street and Sycamore Street streetcar lines.

In 1947, the New York State Public Service Commission (PSC) began proceedings aimed at forcing IRC to declare bankruptcy and petition the federal district court to reorganize. IRC began litigation to test the constitutionality of the statute, but its operating situation became desperate. On July 28, 1947, IRC filed a petition for reorganization under Chapter X of the Bankruptcy Act. Local attorneys John W. Van Allen and Henry W. Keitzel were appointed trustees. During their investigation they discovered the following: IRC's funded debt exceeded value of the property. Failure of company and bondholders to rectify this situation caused funds earmarked for modernization and service improvements to be used for debt reduction. The same excessive debt made it difficult to obtain financing. The privately owned automobile had become IRC's major competitor. Replacing streetcars with buses required destruction of physical property not yet paid for and for which no depreciation funds had been established. IRC was unable to obtain fare increases high enough to cover potential operating deficits.

Sharply inflated wages and material costs were incurred without ability to obtain proportionate fare increases. Abnormally high taxes existed at local, state, and federal levels.

The trustees attempted to solve these problems and place IRC on a sound financial basis by increasing fares to 10¢, reducing operating costs largely through purchase of new buses, refinancing certain previously purchased buses for a longer term, reducing rights of 1,559 outstanding claimants with a value exceeding $7 million to 1,485 claims valued at $1 million, and recommending the passenger transportation business be retained and transferred to the reorganized company but the freight line and the international toll bridge at Lewiston be sold.

In October 1941, several new 3000-series Mack LC 32-passenger buses were displayed outside Buffalo City Hall. These were IRC's first buses with a separate exit door. They were durable and reliable medium-duty buses. Replacement began in 1954, and the last units were retired in late 1958.

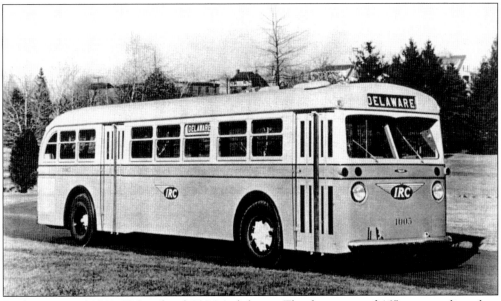

In the spring of 1941, IRC ordered 200 Mack buses. The first group of 165 were medium-duty 32-passenger double-door LCs, 3000–3164, including 10 single-door 33-passenger buses, 3090–3099, for interurban service. The remaining 35 were heavy-duty double-door 40-passenger model CMs 4000–4034. The LCs proved very reliable and long lasting. They were used throughout the system until the last unit retired in 1971. The CMs were assigned to Frontier Division and chiefly used on the Delaware Avenue, Elmwood Avenue, and Grant Street lines. They were retired by 1957.

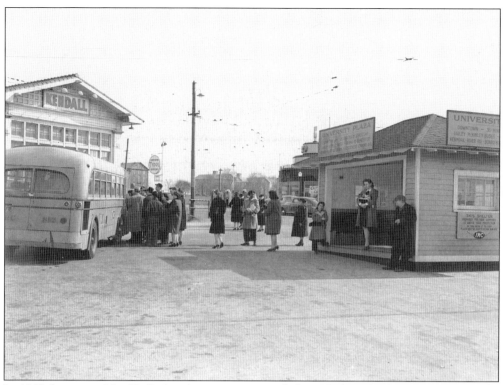

In 1942, bus route No. 19–Bailey Avenue was extended north from Highgate Avenue to the Windermere Boulevard loop at Main Street and the city line.

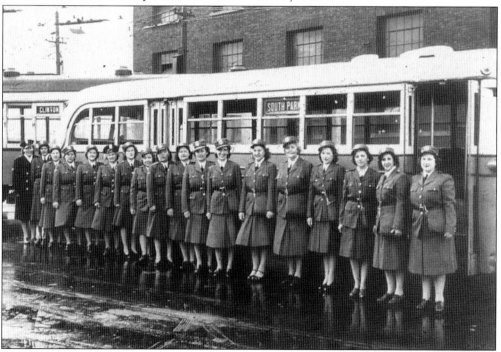

The first group of female bus operators posed for a group photograph in October 1942.

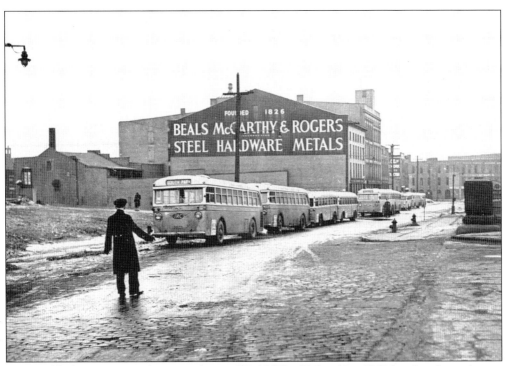

On a cold, damp winter afternoon during World War II, bus No. 3021 heads a line of route No. 16–South Park Avenue buses near downtown.

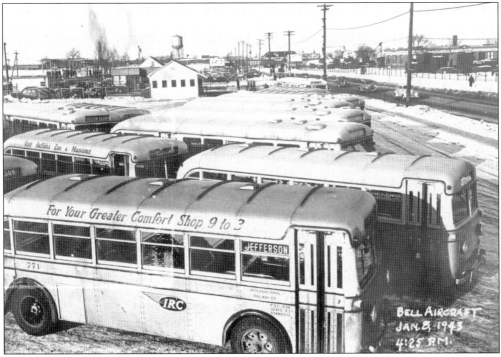

Throughout World War II, buses provided additional service at shift change times to the former Bell Aircraft plant on Elmwood Avenue.

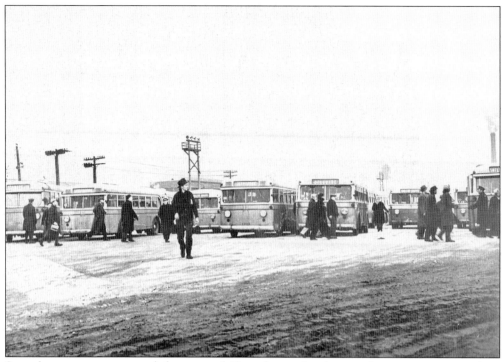

Some bus routes were extended to serve shift workers at local war industry companies such as the Curtiss-Wright aircraft plant on Delavan Avenue.

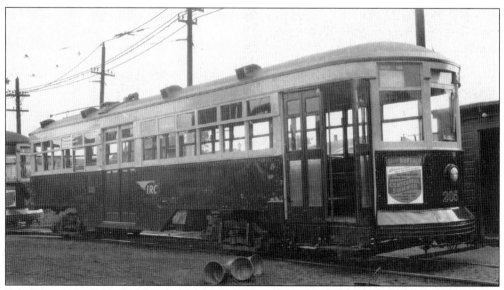

On August 30, 1946, freshly repainted Peter Witt car No. 205 provided sparkling evidence of IRC's continued intent to maintain a good appearance.

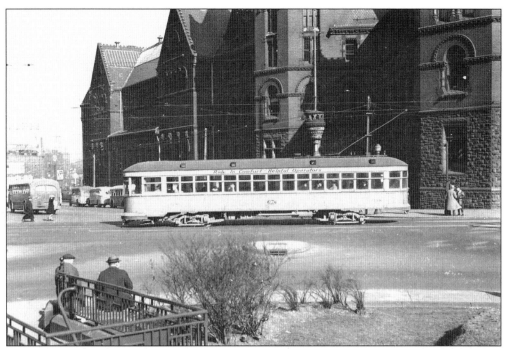

An outbound route No. 4–Broadway car passes Lafayette Square and the Erie County Central library that was also the downtown terminal for Buffalo Transit Buses to suburban communities to the north, east, and south of Buffalo.

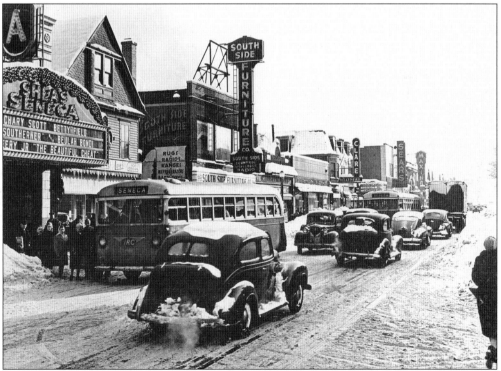

Two IRC buses pass the Seneca Theater on a bitter-cold December day in 1945.

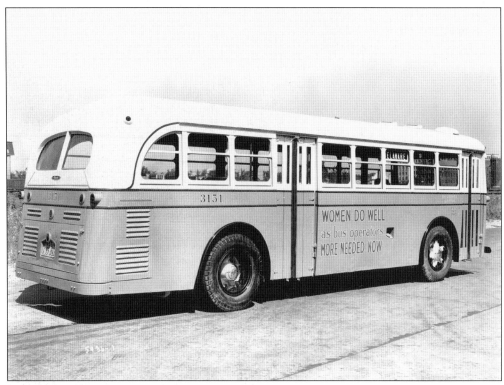

During the war, IRC painted slogans and help wanted advertisements on many streetcars and buses.

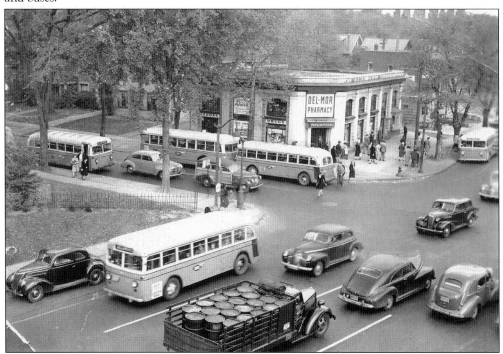

Five buses meet at Delaware and Delavan Avenues in this *c.* 1945 photograph.

Another view of the same corner shows more IRC buses headed for downtown, including a gas-electric.

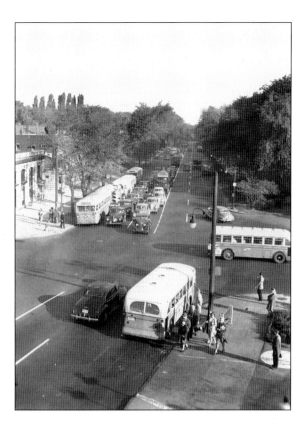

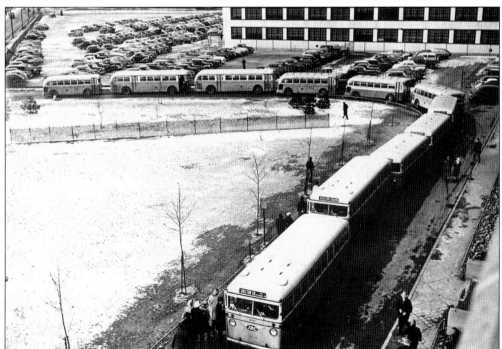

Eleven IRC buses line up outside the Curtiss-Wright plant on Delavan Avenue.

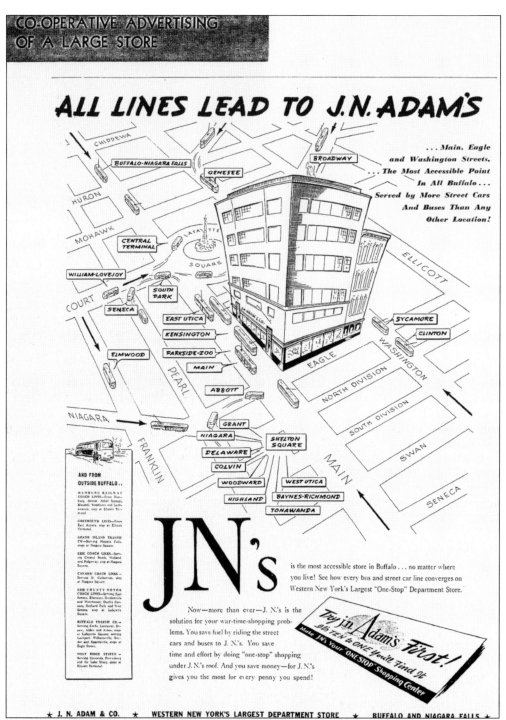

During World War II, many downtown merchants placed advertisements informing their customers how to reach their locations by IRC bus and streetcar services.

Seven

RAILS WERE GOOD, BUT RUBBER IS BETTER

In 1948, 30 percent of IRC's 220 million annual riders still traveled by streetcar. On lines where continued rail operation was contemplated, streetcars and track were maintained in serviceable condition. To improve comfort and performance, two Nearside cars were equipped with two motor trucks and several Peter Witt cars were fitted with rubber bushings to absorb vibration and reduce noise.

Throughout the reorganization, considerable public interest was expressed in modernizing streetcar service. In 1948, the trustees solicited professional assessment of the situation and recommended improvements.

Two transportation consultants advised the trustees that over $10 million would be required to rebuild the existing street railway infrastructure. Of that amount, approximately $7 million was needed to purchase enough new Presidents Conference Committee (PCC) cars to provide all service. Postwar streetcar riding remained heavy, but consultants doubted any IRC streetcar line could generate enough revenue to justify purchase and operating costs of PCC streetcars without a substantial fare increase. Inexplicably, the possibility of purchasing secondhand PCC cars at substantially less cost than new models was never explored.

Trolley coaches were also considered. They offered smooth, quiet, odorless, and economical operation and the ability to carry large numbers of standing riders, did not require indoor storage, possessed the ability to provide curbside service, and could utilize IRC's existing electrical distribution network. Disadvantages were the potential service interruptions when through traffic is disrupted, the inability to provide direct service to major off-route events, and inflexibility to meet future changes in directional flow of traffic without investment in installation of new overhead wires.

Gas buses offered a low purchase price, flexibility in traffic, minimal need to disrupt service, ability to directly serve off-route events, easy adaptability to changes in traffic patterns, more opportunities to through route or interline, low costs to extend service, and the ability to provide express service. Disadvantages included the noxious exhaust emissions, the need for indoor storage, limited carrying capacity, noisy operation when compared with electric vehicles, a ride quality dependent on street surfaces rather than smoothness of rails, potential fire hazards, and fluctuations in fuel prices.

After World War II, many transit systems faced sharply inflated operating costs. Availability of automobiles and gasoline, large-scale population shifts away from downtown, construction

of local expressways, and introduction of television caused dramatic patronage declines. IRC needed a modern image and cost-effective operating strategy to survive. New diesel-powered buses with streetcarlike carrying capacity but without streetcarlike infrastructure proved a difficult argument to beat.

In 1949, IRC hoped to purchase General Motors diesel transit buses but could not obtain financing. Local bus manufacturer Twin Coach did not offer a comparable product. Mack offered to provide financing, so trustees ordered 300 Mack diesel transit buses (60 thirty-seven passenger and 240 forty-five passenger) at a cost of $5.3 million. One hundred sixty buses were delivered during the summer of 1949 to replace 269 prewar Mack buses. The remaining 140 buses, scheduled for delivery in the spring of 1950, were intended to replace remaining streetcars.

As it turned out, streetcars went neither quickly nor quietly.

In the summer of 1949, Buffalo hosted the Eucharistic Congress. Thousands of delegates, lodged in downtown area hotels, attended multiday activities in Delaware Park. To transport them, IRC increased route No. 9–Parkside Avenue–Zoo streetcar service to provide two-minute headway between downtown and Hertel Avenue. Cars made local stops on Parkside Avenue and then continued north to Hertel Avenue where a normally unused switch was activated to permit streetcars to return directly downtown via Hertel Avenue and Main Street. The trusty IRC streetcars performed flawlessly.

The Buffalo Evening News had long opposed IRC's commitment to an all-bus operation. In 1941, it requested Mitten Management to provide a new PCC car for public demonstration. When the request was denied the Evening News arranged for a brand-new Pittsburgh Railways car No. 1264 to be displayed behind the former Memorial Auditorium. The difference between IRC standard-gauge track (four feet eight and a half inches) and Pittsburgh Railways wide-gauge track (five feet two inches) prevented a live demonstration. IRC patrons could only imagine the improved service PCC cars offered.

In January 1950, the Evening News, with the common council's approval, arranged to borrow a trolley coach for an independent three-week public demonstration.

The borrowed coach, Cincinnati Street Railway Marmon-Herrington-built No. 1446, basked in the warm glow of public attention throughout its stay in Buffalo. Six companies donated time and materials to construct a three-block route along Exchange Street east of Washington Street. During the three-week trial, more than 10,000 people enjoyed free rides. With the exception of one dissenting councilman, all were favorably impressed, and the news filled many columns with positive comments.

Not wanting to be outdone, the Buffalo Courier Express attempted to arrange its own demonstration of a PCC car, but nothing came from it. Buffalonians waited another 35 years before modern electric public transportation graced city streets.

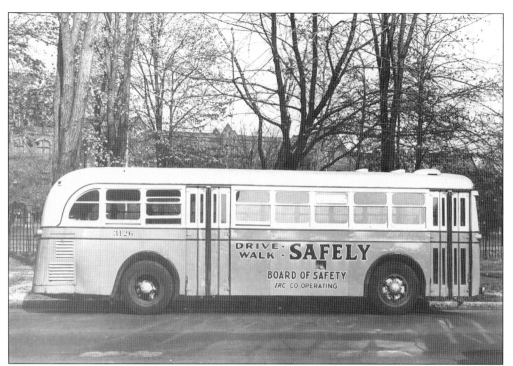

In 1946, a Mack bus, No. 3126, traveled about town extolling the virtues of public safety. These photographs were taken outside the Forest Shop on Forest Avenue between Abbotsford Place and Richmond Avenue.

Fifteen 1936 thirty-two-passenger Yellow Coach model 728 transit-type coaches were purchased from Madison, Wisconsin, in 1946. They were IRC's only secondhand buses. One of them is seen here inside the Hertel Garage. All 3200-series coaches were retired by 1949.

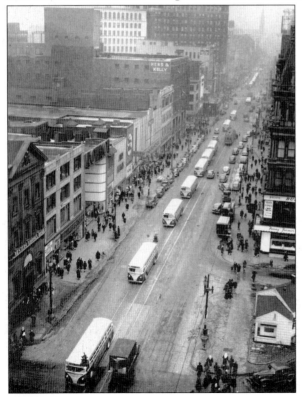

IRC's first postwar buses, Nos. 4100–4149, pass through Lafayette Square in February 1947.

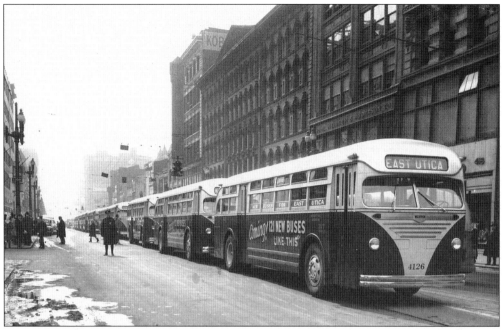

These completely redesigned Mack 41-passenger buses were the first to feature IRC's new red, cream, and silver colors. They certainly brightened up a mid-February day as they passed the original Adam, Meldrum and Anderson (AM&A) store on Main Street.

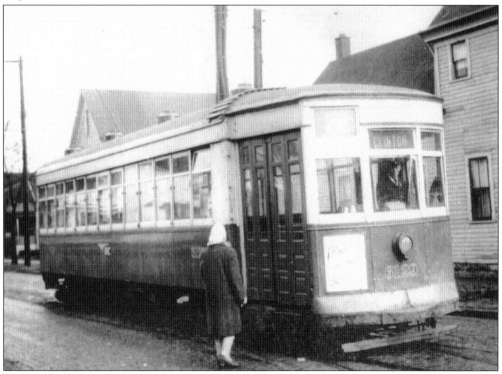

In February 1947, a passenger boards a Nearside car at the route No. 2–Clinton Street wye located at Clinton and Pontiac Streets.

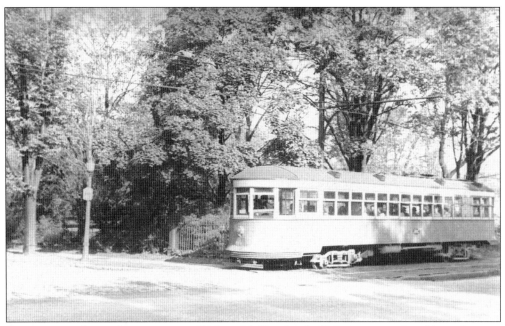

On a sunny September morning, Walter McCausland, IRC director of public relations, photographed this Parkside Avenue–Zoo streetcar at the corner of Parkside Avenue and Jewett Parkway.

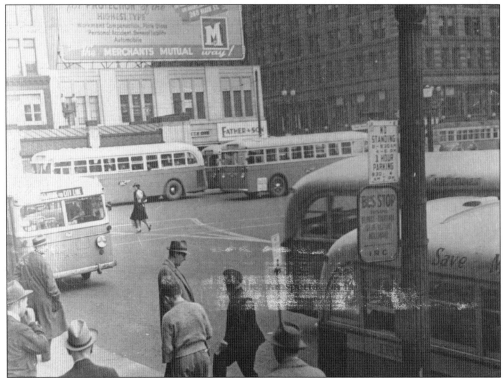

A supervisor provides information to a waiting passenger on a sunny summer afternoon at the Shelton Square terminal.

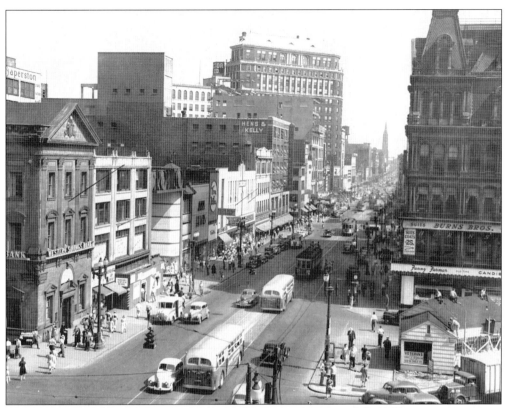
Nearly new Mack buses dominate this view of Lafayette Square in July 1947.

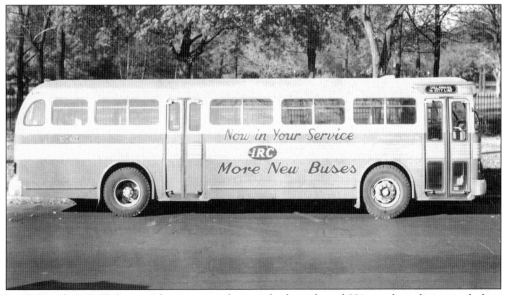
In 1947 and 1948, IRC wanted everyone to know it had purchased 221 new large buses, including 171 locally built Twin Coach model 40S types assembled at 455 Cayuga Road in Cheektowaga next to the airport.

On February 22, 1948, buses replaced streetcars on the Clinton Street and Sycamore Street

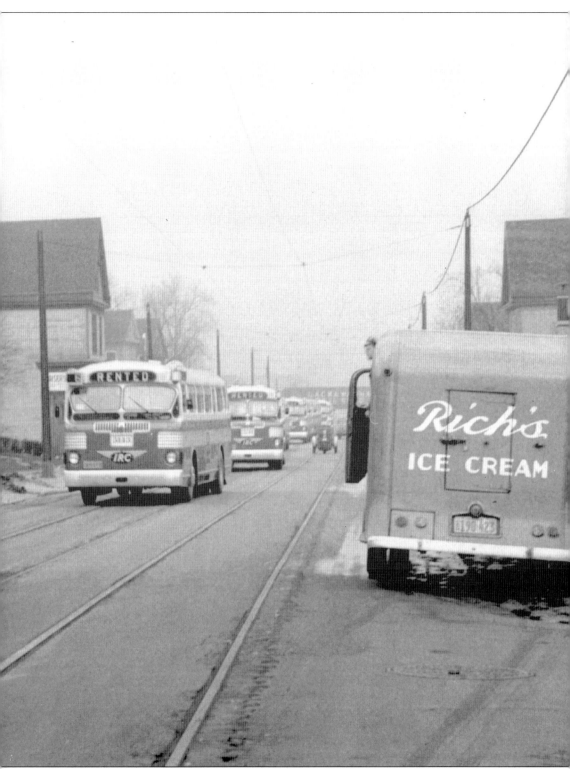

routes. Twin Coach No. 5089 leads a parade of new buses at Sycamore and Lathrop Streets.

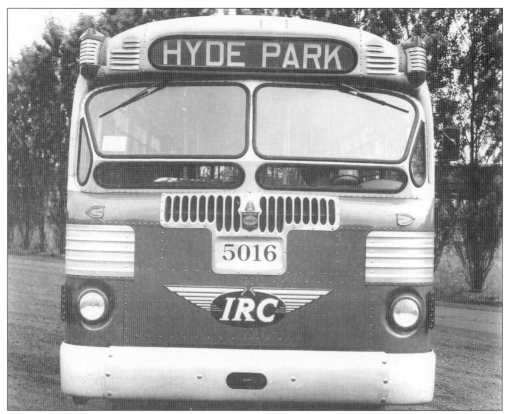

The completely redesigned postwar Twin Coach feature a distinctive six-piece windshield of flat glass for enhanced visibility.

Interiors featured sloped floors to facilitate cleaning and plastic-coated seat rails for safety.

Eight

FROM RAILWAY TO HIGHWAY

On January 1, 1950, the trustees sold the Lewiston-Queenstown Bridge for $150,000. Thereafter IRC was international in name only.

The NFT was organized on June 1, 1950. By mid-month enough new buses had arrived to permit conversion of the Main Street, Parkside Avenue–Zoo, and Kensington Avenue streetcar lines. This occurred on June 18. The three remaining streetcar lines, Broadway, Fillmore Avenue–Hertel Avenue, and Genesee Street, were converted to permanent bus operation on Saturday, July 1, 1950. Both events were widely publicized and well attended.

Six months were required to move the 175 streetcars from Broadway and Cold Spring Divisions to the Hertel Avenue carbarn for storage. The final streetcar to make this journey was No. 6037 the 38th Nearside car built. Its trip occurred on an unrecorded dreary December afternoon in 1950. On December 15, operations of the electric freight line to Lockport were turned over to the Erie Railroad and the substations were turned off. The electric era of public transportation in the Niagara Frontier appeared over.

NFT still carried 200 million riders. Streetcar lines, especially Fillmore Avenue–Hertel Avenue, remained well patronized until their final trips. For two years, streetcars and rails remained idle while NFT directors and staff debated their future. At one point, several NFT representatives traveled to Toronto to inspect a group of soon-to-be-retired streetcars virtually identical to Buffalo's own Peter Witt cars. Around this same time, used PCC streetcars from other cities became available. Sadly NFT failed to pursue either possibility.

When streetcar service ended a number of older employees were left without work. While NFT considered restoring Fillmore Avenue–Hertel Avenue rail service, these loyal employees were retained to scrap various electrical power distribution components. When it became apparent streetcars were unlikely to return, NFT built a temporary electric generator powered by several gas engines from retired Mack buses. These same employees then ran the doomed streetcars under their own power to the far corner of the storage yard. Their car bodies were removed and stacked like piled cordwood, soaked with kerosene, and burned. When this gruesome task ended in 1954, the Hertel Avenue property was sold.

Five opportunities to preserve an IRC streetcar occurred. The Seashore Trolley Museum in Kennebunkport, Maine, and a local railway historical society each wanted one, but neither could raise the required $250 purchase price. NFT closed the Forest Avenue paint shop in 1952, and the property remained vacant until sold in 1956. Teck Garage, the new owner, quickly

discovered six Nearside cars stored inside the building. NFT simply pulled them outside and cut them up.

Former Great Gorge Route car No. 26 served as the line car for the Niagara Junction Railroad until 1976, when it was donated to the Warehouse Point trolley museum. Its mechanical components were used to restore other historic streetcars.

Electric freight locomotive No. P-3 was sold to the Toledo and Easton Railroad near Toledo, Ohio, where it ran into the early 1960s. Its present whereabouts are unknown.

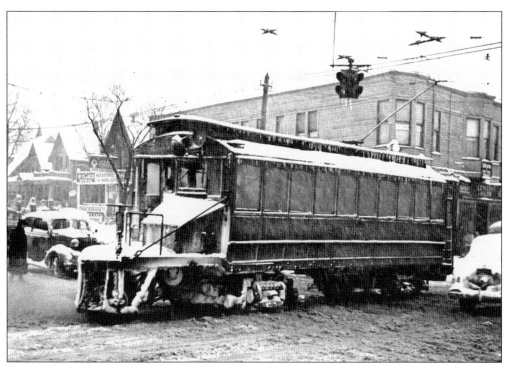

A snow sweeper clears the intersection of Fillmore Avenue and Sycamore Street on New Year's Day 1849.

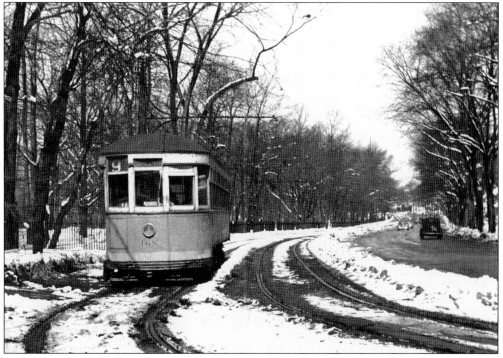

In this view, a Parkside Avenue–Zoo car operates on the reserved trackage alongside Parkside Avenue between Amherst Street and Florence Avenue. It is seen turning into Florence Avenue.

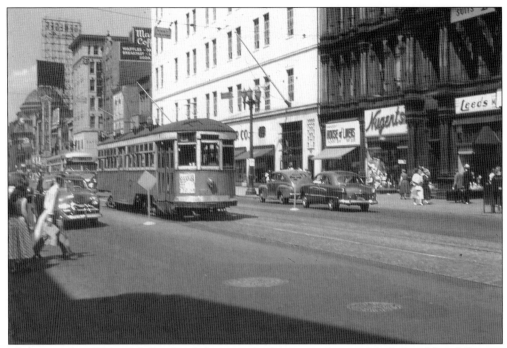

This is another Walter McCausland photograph, this time of a new Mack diesel bus following close behind an IRC streetcar. Both are passing the William Hengerers and Company department store on Main Street at Lafayette Square.

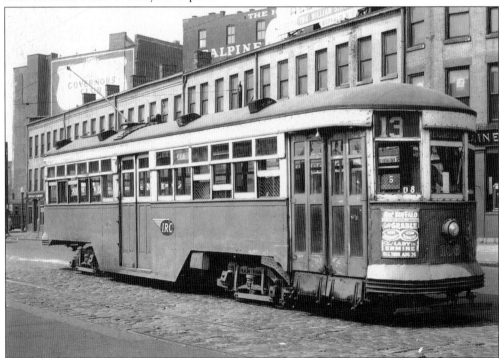

After the East Utica Street line converted to bus operation in 1947, the layover tracks at the former IRC ticket office on the Terrace were used by route No. 13–Kensington Avenue cars.

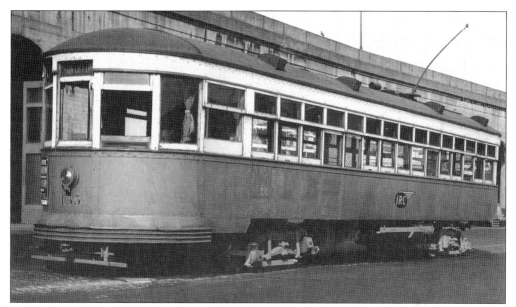

The No. 8–Main Street and No. 9–Parkside Avenue–Zoo streetcar lines' south terminal was located adjacent to the Lackawanna Railroad train shed at Main Street and South Park Avenue. Today this same building is used to store Metro Rail cars.

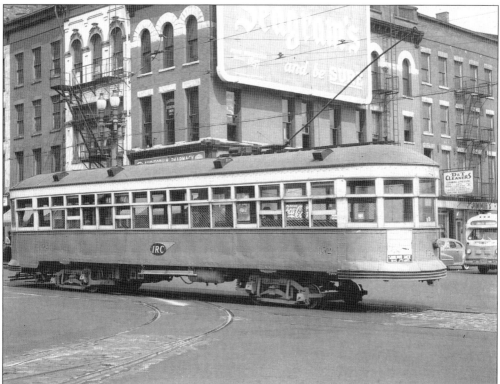

This streetcar has departed from Main Street and South Park Avenue and heads north on Main Street at the Terrace. In the background, a Buffalo Transit bus waits to turn from Exchange Street onto Main Street.

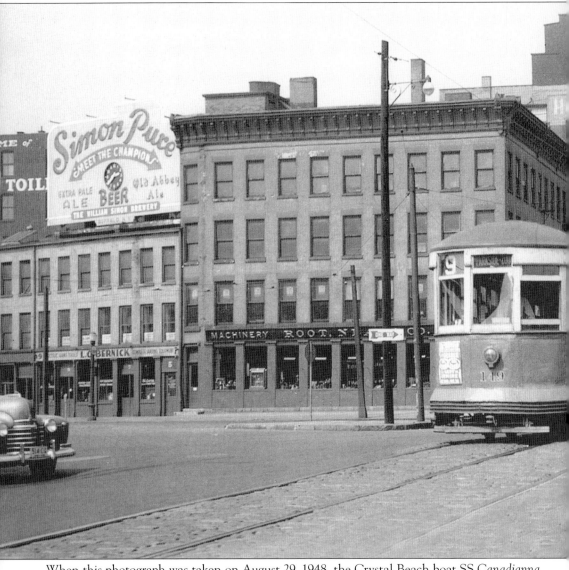

When this photograph was taken on August 29, 1948, the Crystal Beach boat SS *Canadianna* was one of five passenger steamship lines with terminals located at the foot of lower Main Street. Nearby were three main line railroad steam passenger stations served by eight railroads.

Today the passenger ships, rail lines, neighborhood, IRC, buildings, and even this view have disappeared.

A nearly new 1949 Mack diesel bus, an IRC Peter Witt car built in 1918, and a 1939 Buick four-door convertible sedan all share space in this downtown view.

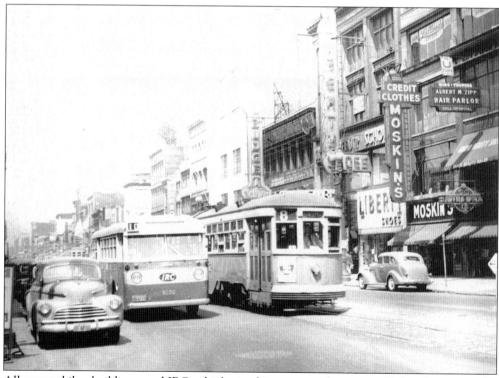

All automobiles, buildings, and IRC vehicles in this scene are long gone. Today this area is the location of Metro Rail's Huron station.

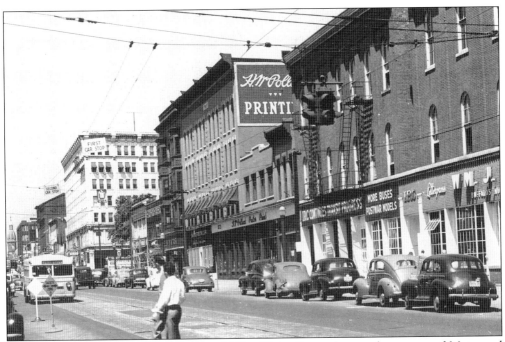

A passenger waits to board an inbound West Utica Street bus at the corner of Main and Virginia Streets.

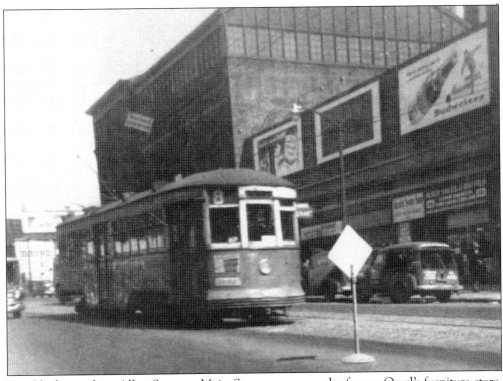

Two blocks north at Allen Street, a Main Street car passes the former Omel's furniture store. Today Metro Rail's Allen-Hospital station occupies this site.

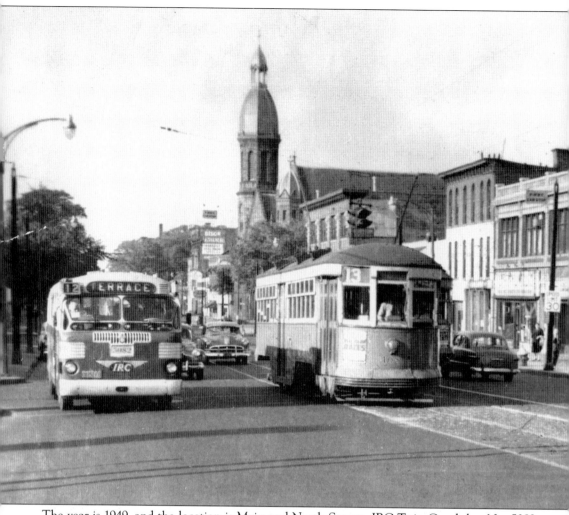

The year is 1949, and the location is Main and North Streets. IRC Twin Coach bus No. 5082 and a slightly older but still capable streetcar pass the present site of the Anchor Bar, birthplace of world-famous Buffalo chicken wings.

Nine

SERVING THE
NIAGARA FRONTIER

The NFT was formed by Buffalo area businessmen and owned by former creditors of the IRC. Roswell Thoma, president of Thoma Paper Box and a successful local banker, served as NFT president from 1950 until 1962. NFT assumed control of IRC operations on June 1, 1950. It inherited a fleet of 729 buses and 175 streetcars providing 602 route miles of service in the cities of Buffalo and Niagara Falls and suburban service to Fort Niagara, Kenmore, Lackawanna, Lewiston, and the Tonawandas.

Several years were required to transition from a street railway to motor coach operation. Along the way, NFT acquired a reputation as an innovative, well-managed, modern company that knew how to promote its product and maintain good will.

NFT was eager to develop charter business because during off-peak hours many buses were available and operators were always eager to earn additional income. In addition to many local charter movements, the popular Sunday Scenic Bus Excursions were offered to various remote venues in western New York State. NFT also purchased several deluxe parlor coaches for longer multiday trips.

NFT buses operated over narrow, congested, and sometimes poorly surfaced streets, which during the winter were pelted with salt. Retaining passengers and attracting new riders required clean and reliable buses. NFT overcame these challenges and, between 1952 and 1965, won the prestigious *Fleet Owner* magazine ME (Maintenance Efficiency) Award 12 times, including 10 consecutive years.

In 1954, NFT owned 649 Mack and 171 Twin Coach buses. All were licensed and available for service. Between 1953 and 1959, forty-six GMC buses and 195 Macks were acquired. When Mack ended bus production in 1960, NFT designed and built its own experimental bus, No. 1000. The experiment proved successful, and NFT hoped to begin large-scale production. General Motors was requested to supply certain mechanical components but declined. In 1968, bus No. 1000 was sold to a private operator in south Florida. NFT relied on General Motors for all future orders and by 1969 had purchased 304 New Look GMC transit coaches.

Seven shops were operated. Cold Spring and Forest were devoted to heavy repair and service. Hertel, Broadway, Frontier, Niagara Falls, and Main/Virginia were for storage and minor repairs. Between 1950 and 1952, $2,771,900 was invested in construction and upgrading repair facilities. A staff of 412 was employed to ensure each vehicle delivered safe, reliable, and cost-effective service.

After 1950, many changes occurred to existing local bus services. When the Niagara Thruway opened in 1959, NFT began weekday express service on several bus routes to the south and east of Buffalo. In December 1960, service was extended to various northern suburbs.

The largest and most innovative service change occurred in 1961 when NFT purchased Buffalo Transit from Jerry Campbell, a former bus salesman for Yellow Coach who enjoyed telling people he had sold double-deck buses to the IBC during the 1920s.

Henry Pensyres, a former bicycle racer, organized Buffalo Transit Company (BTC) in 1930 to operate bus service along Main Street from the city line to Williamsville as a replacement for the Buffalo and Williamsville Railway. Operations expanded as BTC acquired operating certificates from insolvent Buffalo area suburban bus and streetcar operators primarily to the east and south of Buffalo. Campbell purchased BTC in 1943 and Pensyres became an Oldsmobile dealer.

On August 11, 1961, NFT purchased BTC for $1.1 million. BTC remained a separate company while plans were made to integrate operations. On August 6, 1963, BTC and NFT officially merged. All BTC 36- and 45-passenger buses and both garages were sold. Newer, larger buses were integrated into the NFT fleet where they ran for many additional years. By the summer of 1965, all former BTC suburban routes operated as extensions of NFT local routes.

Roswell Thoma passed away in November 1962. A modest staff reorganization followed. Business continued much as it had for many years but times had begun to change, and to survive, NFT had to change as well.

Owl service on 18 routes was discontinued in 1962. The remaining gas-powered Twin Coaches were retired when Niagara Falls service ended on December 31, 1964. As additional suburban expressways opened, Buffalo's population declined and fewer people rode buses to downtown. NFT began losing discretionary riders. Expenses rose while profits declined. Various merchant associations periodically chartered NFT buses to provide free transportation to downtown and suburban shopping centers and federal funds became available for express service via local expressways, but the era of the large, locally and privately owned profit-oriented transit provider was rapidly concluding.

In 1968, NFT carried 66 million riders. A 42-day strike occurred in the summer of 1969. By 1973, patronage plummeted to 33 million. Innovation and progressive thinking yielded to declining ridership, fare increases, and operating deficits.

In 1967, the New York State legislature created a public corporation known as the Niagara Frontier Transportation Authority (NFTA) to acquire and develop air, water, and surface transportation facilities in Erie and Niagara Counties. NFTA was also responsible for implementing a policy of unified mass transportation. A Transit Development Program, mandated by the federal government, was created. It envisioned three elements: a regional bus transportation network, the design and construction of a downtown Metropolitan Transportation Center, and the design, engineering, and construction of a heavy-rail rapid transit system that began operating in 1984.

In 1973, the NFTA and NFT began serious purchase negotiations. On January 29, 1974, William Miller, NFTA chairman, and NFT president Alex Trumble announced formal agreement for sale of NFT to NFTA for $9,676,000. The tentative takeover date was scheduled for April 1, 1974.

Shortly after midnight on April 1, 1974, No. 6318, a New Look Mack built exclusively for NFT in 1958 and driven by operator Alfonse Satchez, departed from downtown via route No. 12–East Utica Street. Several fare-paying passengers were joined by representatives from NFT and NFTA. It was a quiet ride. When the bus returned to the Cold Spring Garage, it stopped momentarily to discharge its final passenger and then pulled inside.

NFT had reached the end of the line.

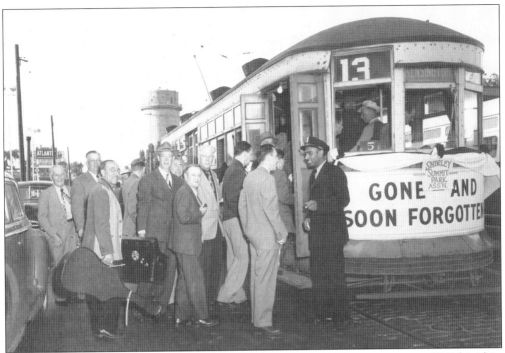

Ansel Cureton was among the earliest African American streetcar motormen IRC hired in 1942. On June 18, 1950, he greets several professional musicians as they prepare to serenade route No. 13–Kensington Avenue streetcar passengers on the final trip.

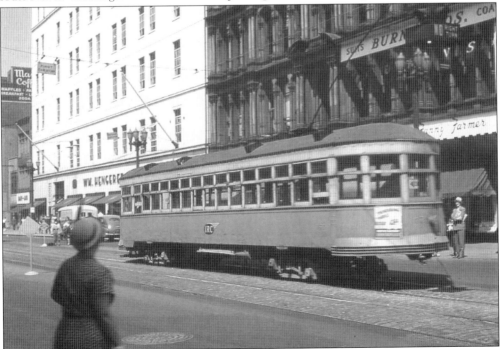

A properly attired woman waits to cross Main Street. Perhaps she is on her way to lunch at Hengerer's Tea Room.

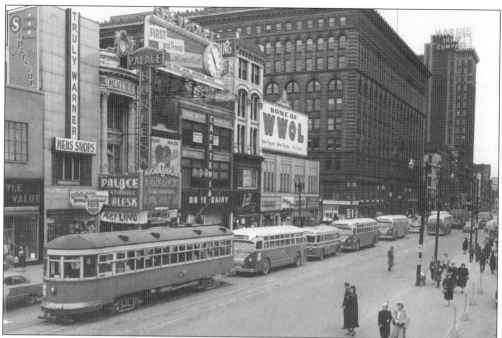

On a balmy spring afternoon in 1950, the afternoon rush has begun. A 1949 Ford and a 1917 Kuhlman-built IRC streetcar prepare to race away from the traffic light at Main and North Division Streets. A variety of Mack and Twin Coach buses obediently follow. Urban renewal erased this entire block of established self-sustaining local businesses and replaced them with a four-lane divided street.

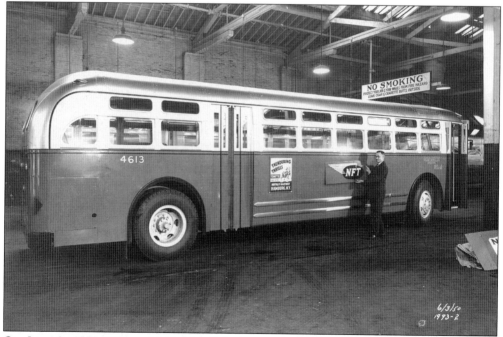

On June 3, 1950, Walter McCausland, longtime director of public relations, displays an experimental NFT logo up to new Mack diesel bus No. 4613.

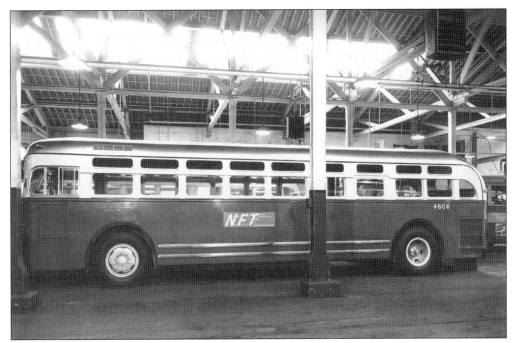

Bus No. 4606 displays the winning design.

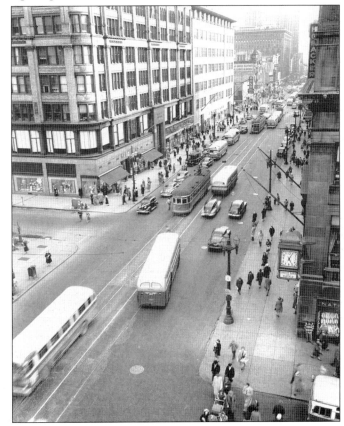

It is just past 5:00 p.m. and time for IRC has expired. Old streetcars and new buses compete for space on Main and Court Streets. Two Buffalo Transit buses pass Woolworth's as they near their downtown terminal.

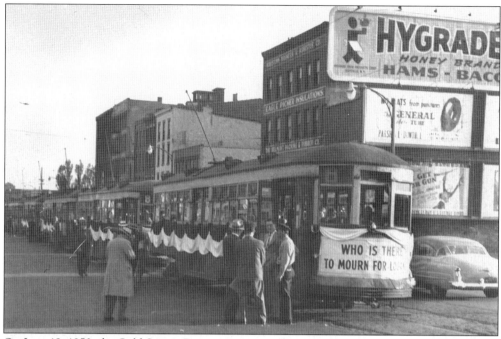

On June 18, 1950, the Cold Spring Division streetcar lines were converted to bus operation. Two cars from each affected line, for a total of six, line up for the final trip at Main and Perry Streets.

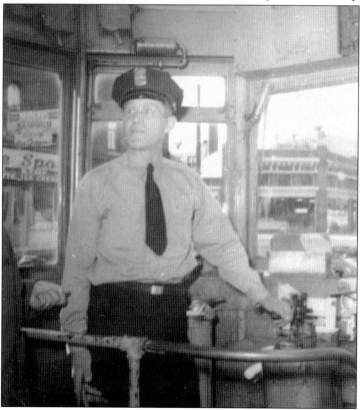

A streetcar motorman stopped at Main and Lafayette Streets to await instructions from the supervisor on the final day of Main Street service, June 18, 1950.

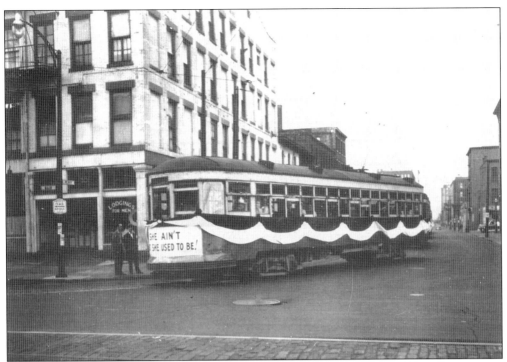

The last Kensington Avenue car has just turned from East Ferry Street onto Main Street.

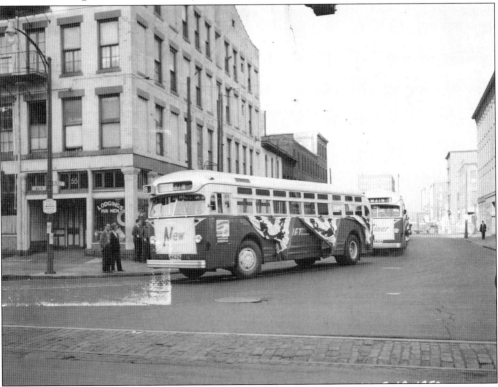

The first Kensington Avenue bus immediately followed the last Kensington Avenue streetcar.

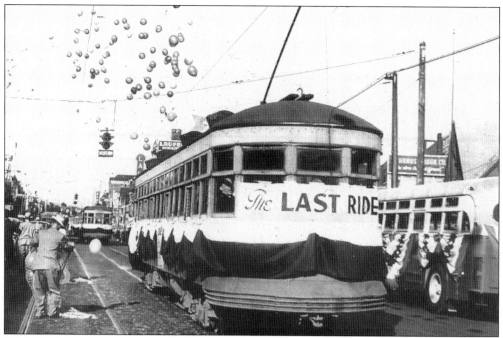

On Saturday July 1, 1950, streetcar service on the Broadway, Fillmore Avenue–Hertel Avenue, and Genesee Street lines ended. At 6:30 p.m., two cars from each line met at Broadway and Fillmore Avenue and then proceeded downtown for the last time. As they returned about an hour later, balloons were released to mark the end of the streetcar era in Buffalo. The last car in the procession is returning to the Broadway car house.

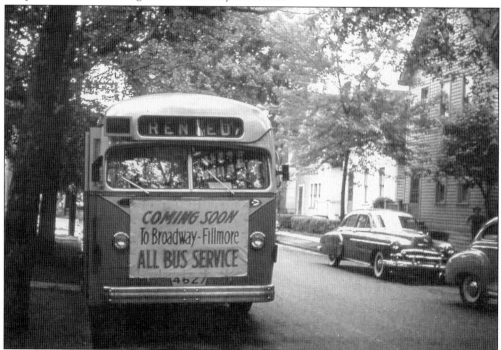

A new Mack bus pauses near the south terminal of the Fillmore Avenue–Hertel Avenue line.

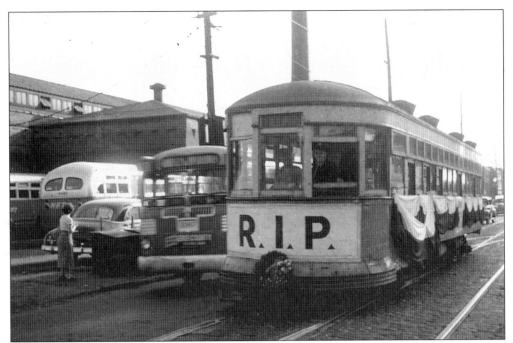

At approximately 7:45 p.m., the last streetcar to operate in revenue service has arrived at the Broadway Division car house. A Buffalo-built Twin Coach bus, en route to the outer terminal at Broadway and Halsted Street, pauses alongside, while in the background new Mack buses await their first trips.

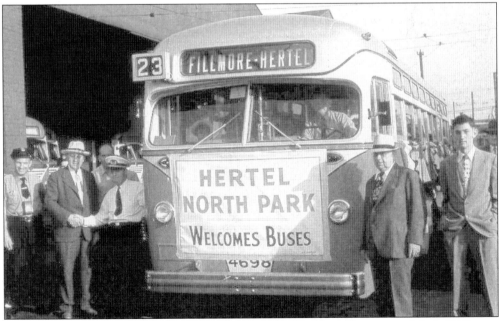

Admiring passengers surround a new bus parked at the Broadway Division on July 1, 1950.

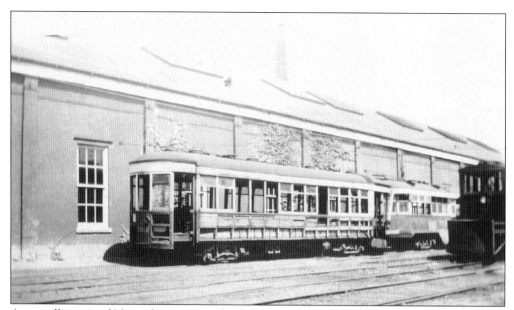

A partially stripped Nearside car sits in the Cold Spring storage yard.

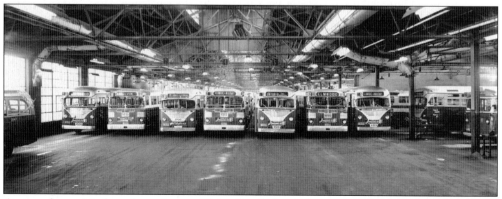

A row of new Mack and nearly new Twin Coach buses line up inside the Frontier Division garage. Some older Macks also appear in this scene.

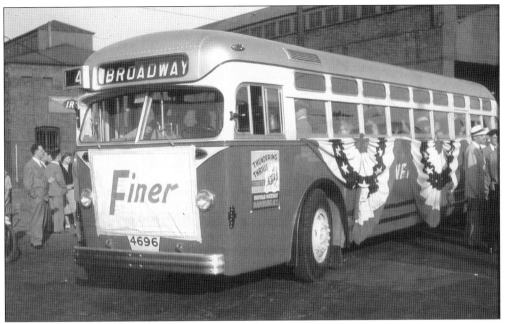

Another new Mack bus waits at the Broadway Division garage.

In 1955, recently delivered GMC bus No. 7022 is southbound at Fillmore Avenue and Rockwell Street immediately south of Main Street.

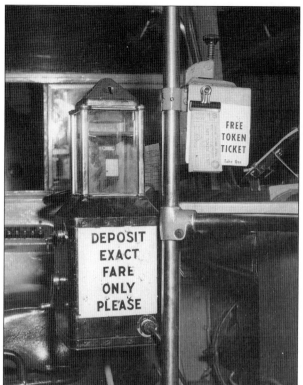

In the days when bus operators made change, and prior to 1954, the Johnson type D electric fare box was the NFT standard. It collected and registered individual fares and returned change to the operator so he or she would be able to make change for passengers throughout the workday. Reconciliation and pilfering were constant problems, so in 1954, NFT changed its fare collection system to utilize fare boxes with locked vaults. Operators continued to make change until 1968.

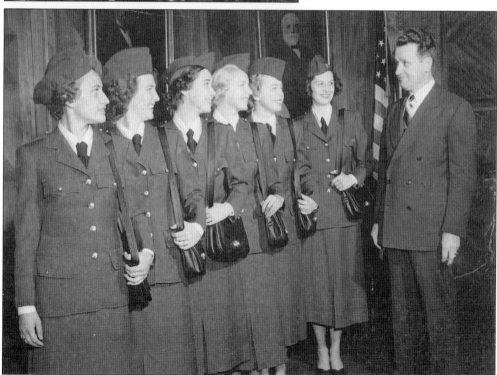

Buffalo mayor Joseph Mruk casts an admiring eye on the newest NFT cadets in 1952.

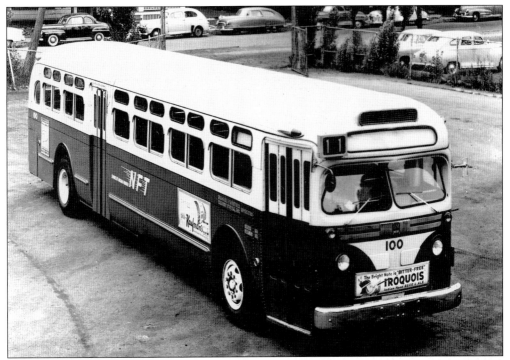

NFT purchased its first GMC transit bus in September 1953. It was later renumbered as 7000. It featured the famous 6-71 series Detroit Diesel engine, hydraulic V drive, and GM's unique air-ride suspension.

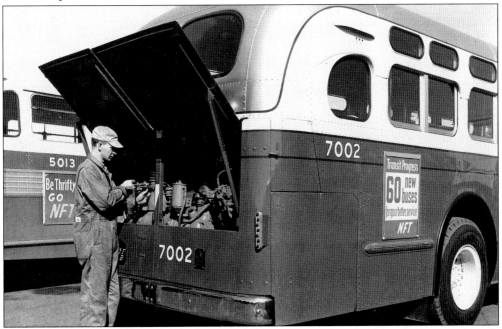

Thirty additional identical buses, Nos. 7001–7030, were acquired in 1954 to run a side-by-side comparison of fuel mileage with 30 new Mack buses, Nos. 6000–6029. A mechanic at Frontier Division prepares No. 7002 for revenue service.

Thirty new GMC buses parade past Buffalo City Hall in April 1954.

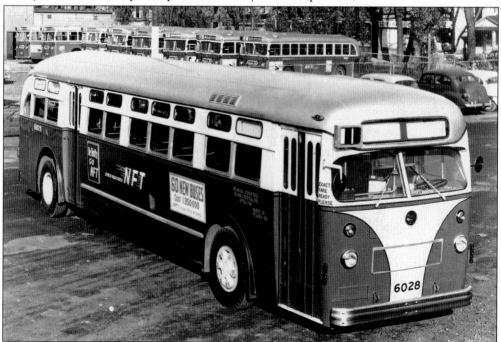

Thirty new Mack C-49 DT diesel transit buses were also acquired to run a side-by-side comparison with the 7000 series GM TDH 5106 models. One is seen at Cold Spring Division before entering service in October 1954.

The four-cycle Mack diesel engine provided slightly better fuel mileage than the two-cycle 6-71 GM diesel. So in 1956, NFT purchased 60 additional Mack C-49 DT buses, Nos. 6100–6159. They were NFT's first Mack buses equipped with air suspension. All were retired in 1968. Today one bus, No. 6137, remains in operating condition. In November 1963, No. 6132 is seen operating on the former route No. 17–Central Terminal line. The 6000-series buses were retired in 1969, but No. 6012 survives in the hands of a private collector.

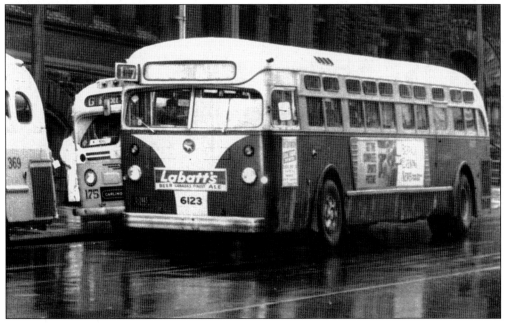

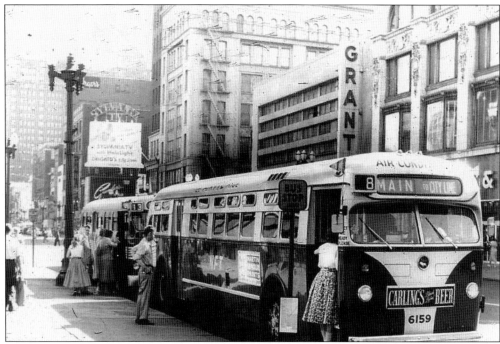

Three 6100s featured air-conditioning. One air-conditioning unit was removed and installed in the mechanical department offices, where it continued to perform reliably for many additional years.

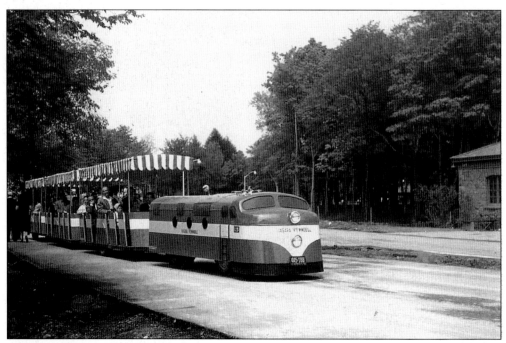

Edward J. Tanski designed and supervised construction of the Viewmobile in 1956. A Ford tractor engine powered the locomotive. The Viewmobile provided tours of the Niagara Falls State Park for many years.

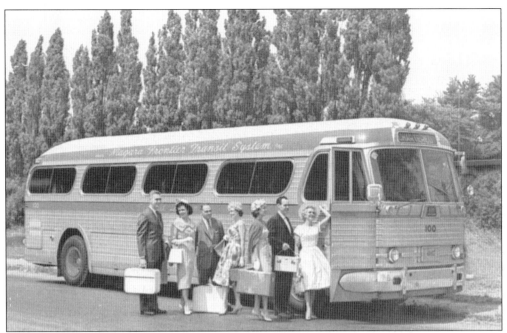

In 1956, NFT purchased two GM model PD 4104 parlor coaches for long-distance premium charter service.

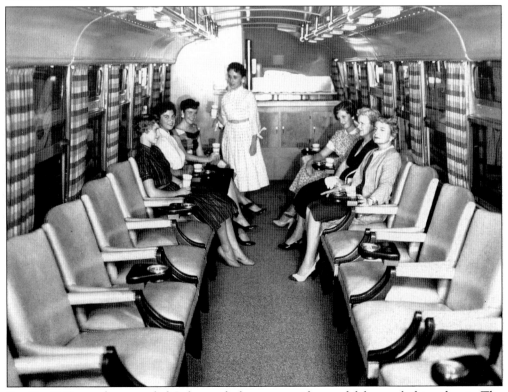

Bus No. 4149 was also upgraded. It featured a lavatory, wet bar, and deluxe upholstered seats. The NFT logo was etched into the globes for the ceiling lamps.

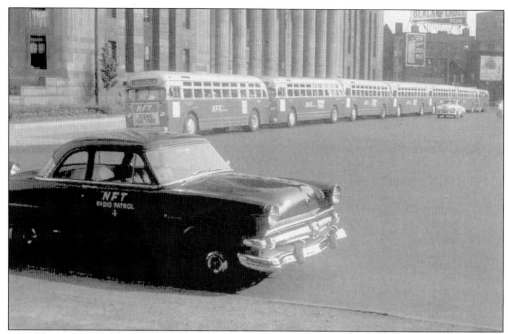

From 1952 until 1962, NFT operated periodic Sunday excursions to interesting places within 150 miles of Buffalo. It was not uncommon for 30 buses to participate in these movements. In early 1954, a group of buses prepares to depart from in front of Buffalo City Hall. Note the supervisor car, a rare 1954 Ford business coupe.

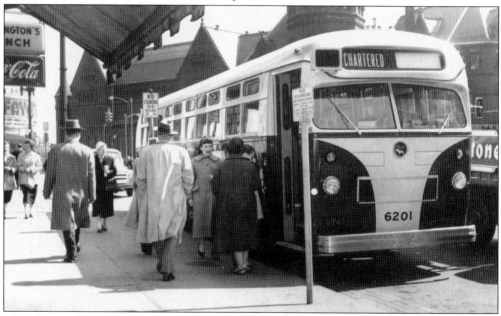

Mack buses Nos. 6200–6244 arrived in early 1957. Their luxurious interiors featured bright marbleized floors, pleasing pastel colors, double rows of florescent lighting, and deeply upholstered two-tone seating. The rear seat wrapped around the bus, and illuminated colored photographs of local scenes were located in each corner. No. 6201 is on public display in front of the Rand Building in April 1957.

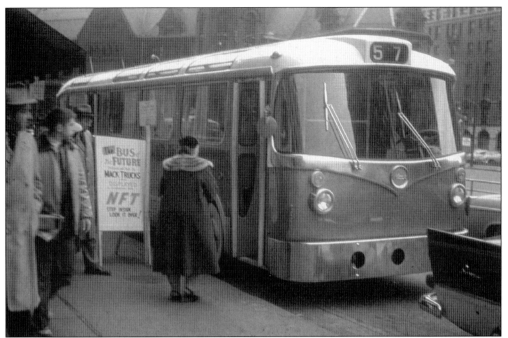

Also in 1957, Mack displayed its "Bus of Tomorrow" in front of the Rand Building. This bus featured modern styling and large panoramic windows. Some of its styling was integrated in what became known as the New Look Mack. The Bus of Tomorrow appeared in many United States and Canadian cities. Eventually it was sold to Schenectady Transit where it continued to operate until being destroyed in a garage fire in 1969.

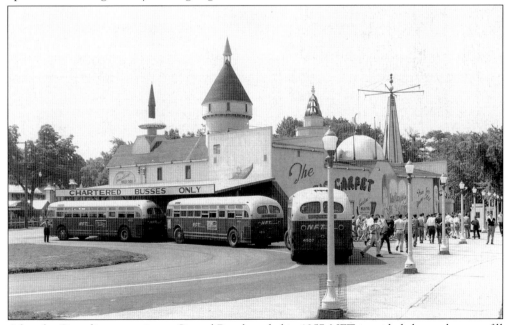

After the *Canadianna* service to Crystal Beach ended in 1957, NFT provided charter buses to fill the gap. Three of them lay over at the charter bus parking lot at the Crystal Beach Amusement Park in 1958.

Looking south toward Dominion Road, a crowd of people head from the buses toward the park entrance.

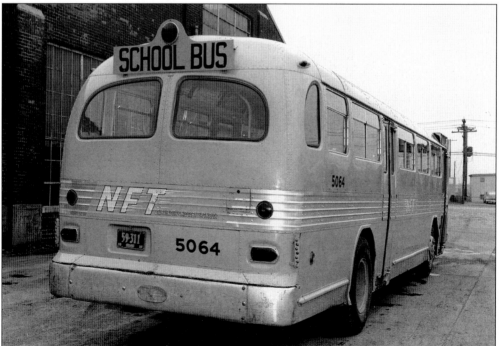

In 1958, NFT repainted and equipped several Twin Coach buses to provide contract school bus service in the Tonawandas.

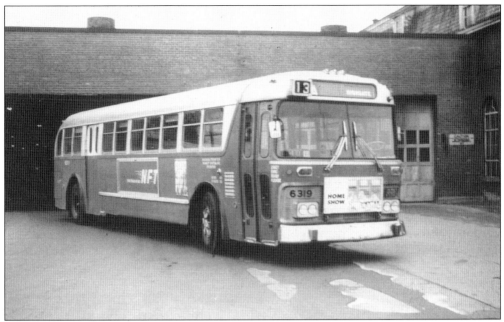

NFT's final order of Mack buses were the sixty 6300-series coaches received in late 1958. They were specially designed by Mack for NFT and featured all the luxuries of their predecessors but also had comparatively larger windows, Mack's own double acting air suspension, and a specially designed front end. They last operated in the spring of 1976.

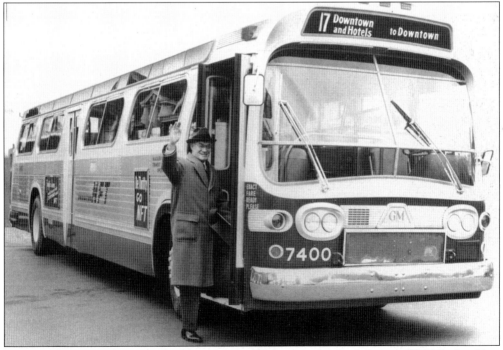

In December 1960, director of public relations Walter McCausland shows off NFT's first New Look GMC transit bus. Note the continued use of uppercase and lowercase lettering, a tradition dating from the IRC era.

This bus was one of many 45-passenger GMCs sold to the Alexandria, Bancroft, and Washington lines near Washington, D.C., and the Waukegan–North Chicago system north of Chicago.

NFT renumbered former BTC buses in the 600 and 700 series. This former BTC bus was repainted for the annual United Way campaign in about 1970.

Buffalo Transit acquired the first New Look GMC transit buses in the Buffalo area in March 1960. Originally numbered 340–349, NFT renumbered them 700–709. They ran until 1978. One coach was converted to a vault bus in the late 1970s.

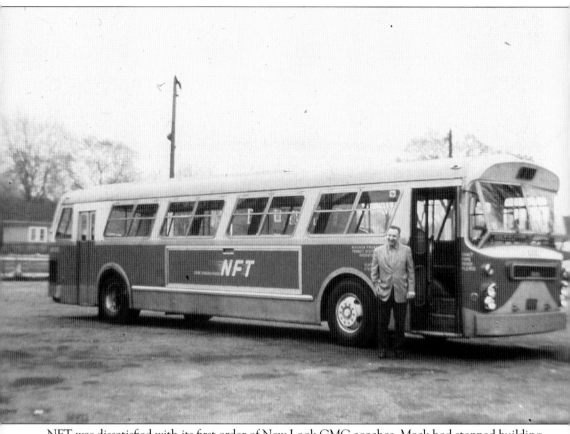

NFT was dissatisfied with its first order of New Look GMC coaches. Mack had stopped building buses in 1960, so at the urging of company president Roswell Thoma, the mechanical department designed and built a revolutionary transit-type bus. Bus No. 1000, as it was known, featured a weight-saving aluminum Hino diesel engine coupled to a smooth-shifting European-manufactured hydraulic transmission. The exit door was located behind the rear wheels in hopes of reducing passenger injuries. Both step wells and body skirt panels were of fiberglass construction, the first American bus to be so equipped. A full-vision windshield was obtained from the Flxible Corporation. The experiment was both an engineering and operational success. NFT hoped to begin large-scale production. General Motors was asked to supply certain component parts but refused. In 1968, Bus No. 1000 was sold to a private operator in south Florida where it operated as a sightseeing bus in Key West for several years and then ended its career hauling migrant workers before being left to sit alone in a field near Homestead, Florida.

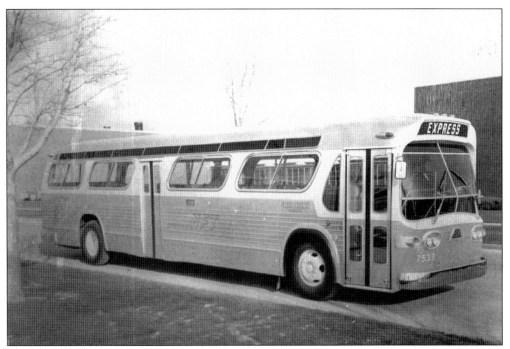

In 1964, NFT retired the last Twin Coaches and began replacing Mack diesels acquired in 1949 and 1950 with New Look GMs. By 1969, it had acquired 314 coaches. No. 7523 was photographed at the GM factory prior to delivery in 1964.

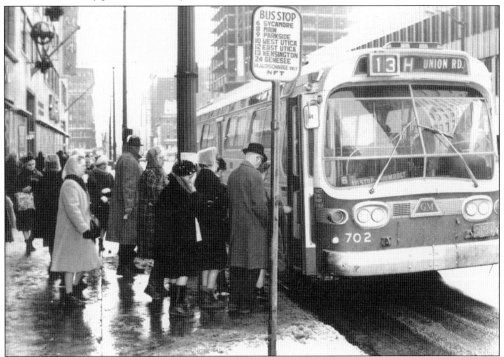

In 1966, former Buffalo Transit No. 342, now NFT No. 702, stops in front of Woolworth's on Main Street in downtown Buffalo.

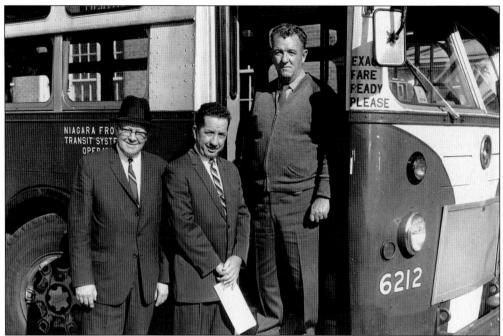

From left to right, former Cold Spring district supervisor John Crumish, an unidentified gentleman from the Buffalo Board of Education, and longtime operating employee and later president of the Amalgamated Transit Union (ATU) Local 1342 Clayton Stephenson appear with NFT Mack bus No. 6212 sometime in 1970.

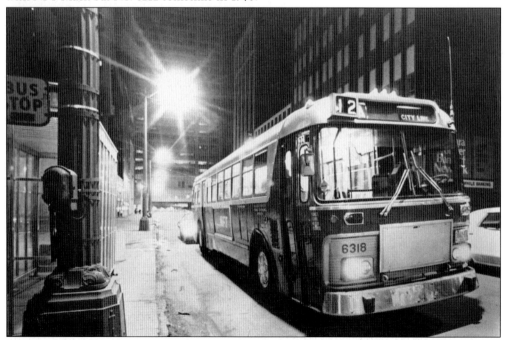

To mark NFT's passing on April 1, 1974, No. 6318, a New Look Mack delivered in December 1958, was selected to operate the final trip. It has stopped at Main and Swan Streets to pick up a few final passengers before heading to the city line.

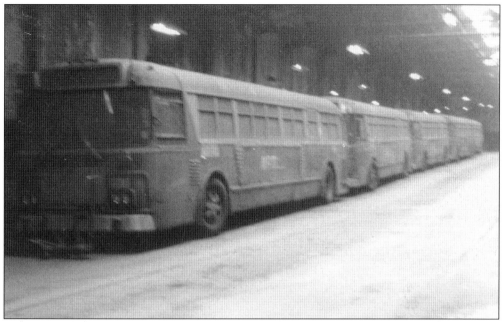

Many Mack buses were placed in storage during 1971. Here is a row of serviceable 6300-series buses at Broadway Garage in 1974.

NFT purchased two heavy-duty Dodge trucks in 1961.

After World War II, IRC acquired several military surplus jeeps in kit form and assembled at Cold Spring shops. They were used to move disabled buses.

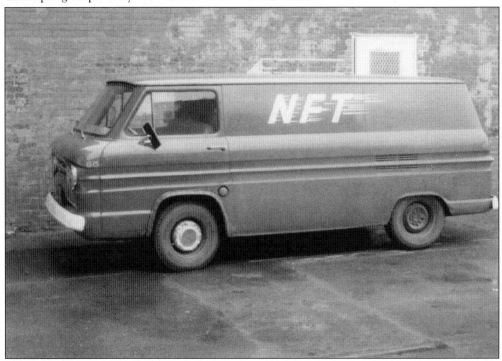

When two-way radios were installed in 1961, NFT purchased this Corvan as a radio repair truck.

In 1950, a compressor truck does a minor track repair job at Main and Carlton Streets.

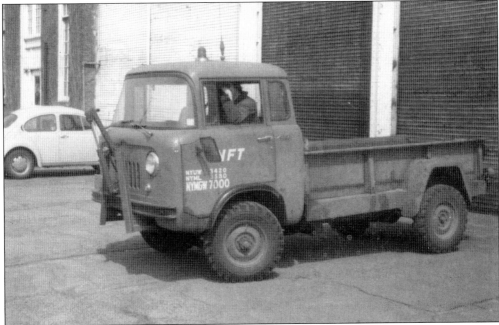

Several forward-control jeeps were purchased for snowplow duty in the late 1950s.

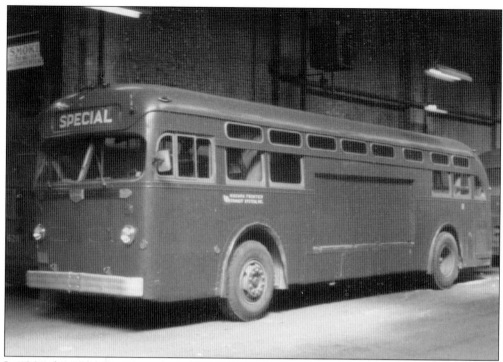

In 1964, this Mack bus was converted to a vault truck.

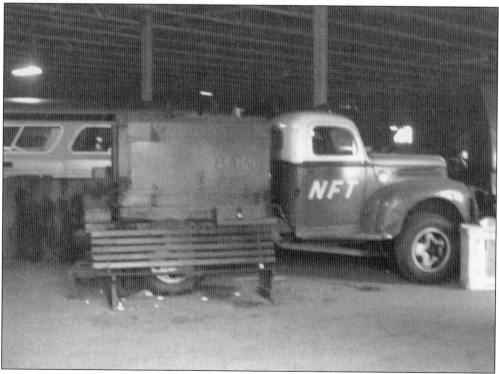

This 1947 Ford, equipped with Marmon-Herrington all-wheel drive, was used to plow the yard at Cold Spring.

Ten

THE STREETCAR'S REVENGE

Federal and state funds to acquire tangible assets of seven privately owned local bus operators were awarded in May 1973. Later that year, anticipating revenue operation, NFTA created a subsidiary corporation known as NFT Metro. Sale of NFT was announced on January 19, 1974. The takeover occurred on April 1. On May 12, the City of Niagara Falls surrendered operation of its Niagara Falls Municipal Transit System to NFTA. In the following months, transit operations of Lockport Bus Lines, Grand Island Transit, D&F (Dunkirk and Fredonia) Transit, and T-NT (Tonawanda-North Tonawanda) Transit were also acquired and amalgamated into the authority's regional bus transportation network.

Under the leadership of NFTA urban transportation planner Gordon J. Thompson, planning and preliminary engineering were undertaken for a high-platform heavy-rail rapid-transit system featuring subway and elevated operation from downtown to the Audubon New Town area of Amherst. Community opposition to this concept resulted in a complete redesign of the proposed rail system. Greater portions of the line were placed underground. Construction costs greatly increased. Instead of an 11-mile subway/elevated heavy-rail rapid-transit system, the project became a seven-mile low-platform light-rail subway-surface line from downtown to the State University of New York at Buffalo's South Campus.

Metro Rail opened in stages. Aboveground service in downtown began October 9, 1984. On May 18, 1985, underground service to the Amherst Street station began. The remaining underground portion of the line to South Campus opened on November 10, 1986.

Today's Metro Rail system operates along and under Main Street from the Cobblestone Historic District and downtown entertainment area to the university station just inside the city line. Twenty-seven cars serve eight underground and seven surface stations on the downtown pedestrian mall. Approximately 28,000 passengers are carried each weekday, making this compact rail line one of the most heavily patronized North American light-rail systems.

On September 2, 1985, shortly before the final segment of Metro Rail opened, a small suburban transportation company, Buffalo Motor Coach (BMC), extended its bus route from the North Campus of the State University of New York at Buffalo to its South Campus at Main Street and the city line. This service was open to the public, but its primary market was the resident transit-dependent university students and staff. To attract riders, BMC used elderly but well-groomed vintage GMC city transit buses. This strategy paid off. While BMC buses were older than most of their passengers they were also safe, reliable, and warm. They became an instant success with a loyal following.

On September 5, 1991, BMC service was extended to the LaSalle Metro Rail station and agreement for through ticketing was reached with Metro. For many years, BMC provided owl service Thursday through Saturday evenings and bus operators made change. All in all, it was a remarkable reminder of an earlier era in public transportation.

Sadly all good things must end. Despite outstanding records for reliability and safety, changing market conditions and sharply increased operating costs began to cast a long, dark shadow over the little bus company that could. In the early hours of a mild November morning in 2002, the university service quietly and uneventfully ended.

Sic transit gloria mundi.

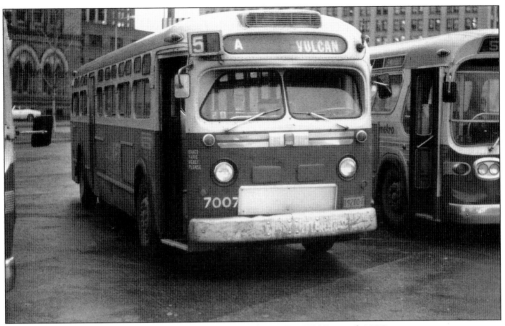

NFT Metro retained many older NFT buses, such as No. 7007, until 1979.

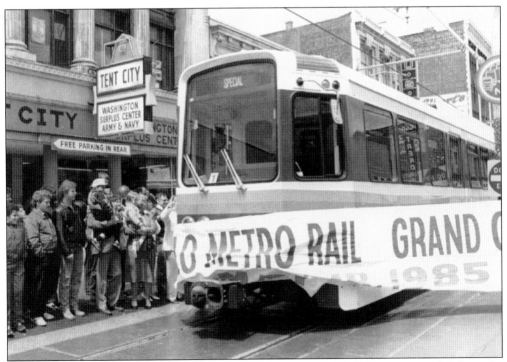

Metro Rail surface operation began in 1984. On May 16, 1985, service was extended from the theater station on Main Street to the underground station at Main and Amherst Streets. The first inbound train is seen arriving at the theater station on opening day.

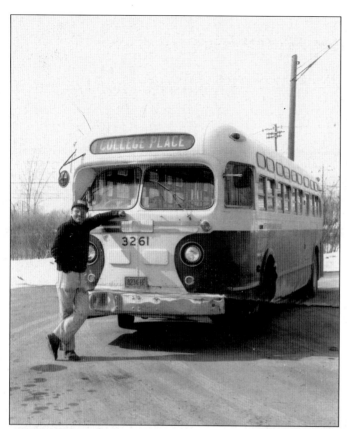

On a bitter cold February day in 1987, BMC president and chief executive officer D. D. Bregger took a few moments from his hectic schedule to pose with BMC No. 3261, a 1954 GMC transit bus originally owned by the South Carolina Electric and Gas Corporation in Columbia, South Carolina.

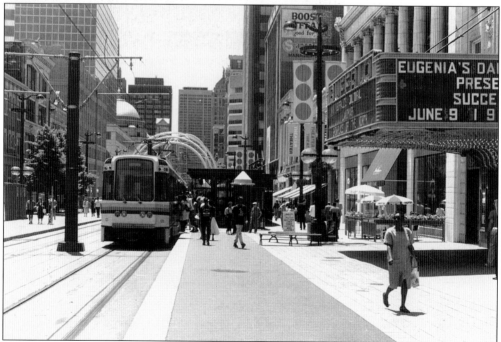

On another day, an inbound train stops in front of the majestic Shea's Buffalo Theater.

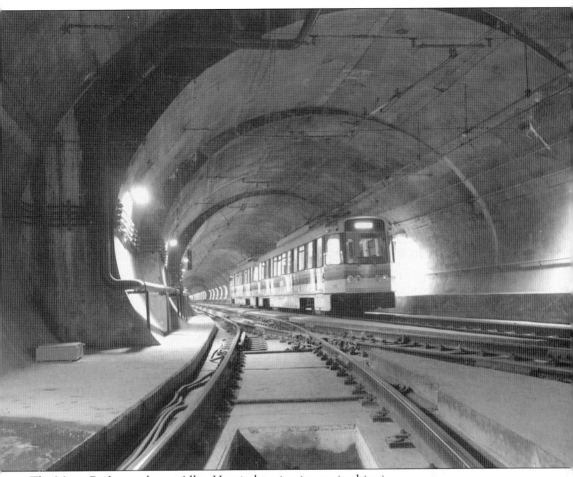

The Metro Rail tunnel near Allen-Hospital station is seen in this view.

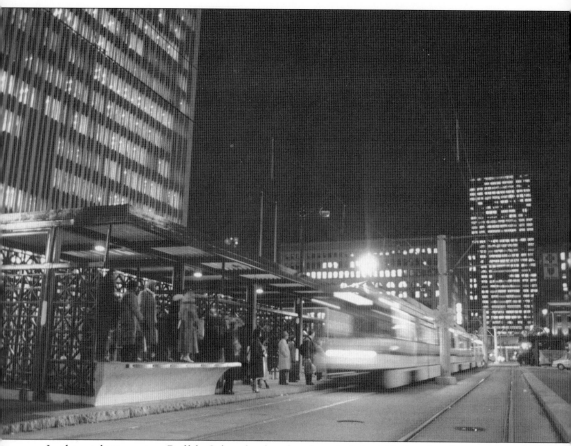

In this nighttime view, Buffalo Sabres hockey fans board a Metro Rail train after a game.

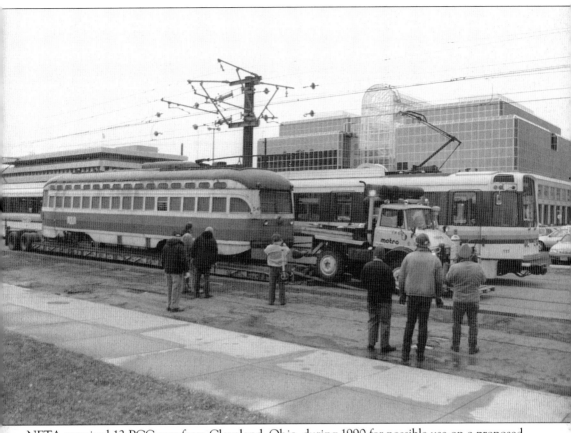

NFTA acquired 12 PCC cars from Cleveland, Ohio, during 1990 for possible use on a proposed Metro Rail branch from LaSalle station to the Tonawandas. Unfortunately, local operating funds could not be obtained and the cars were eventually sold to a moribund streetcar operation in Brooklyn.

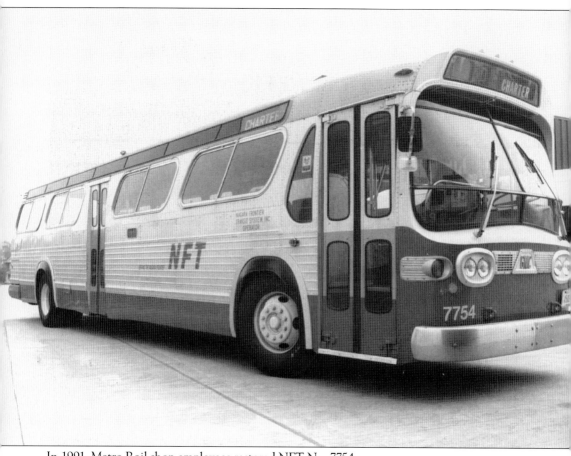

In 1991, Metro Rail shop employees restored NFT No. 7754.

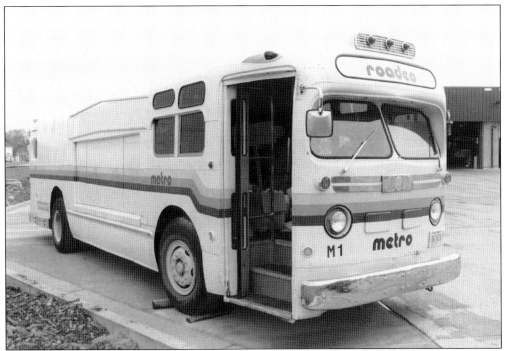

When NFTA purchased a new fare collection system in 1988, this 1957 GMC vault bus, originally built as NFT No. 7101, was used for several years to serve hot dogs at Metro bus rodeos. Today it survives in a private collection.

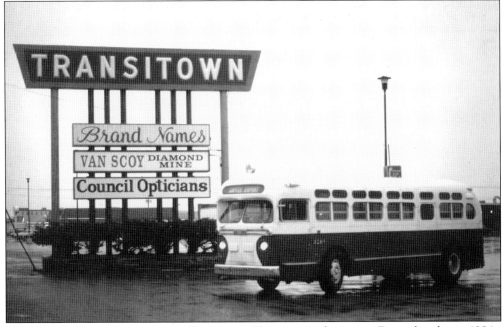

BMC No. 3261 proudly poses at its Transitown Plaza terminal on a wet December day in 1984.

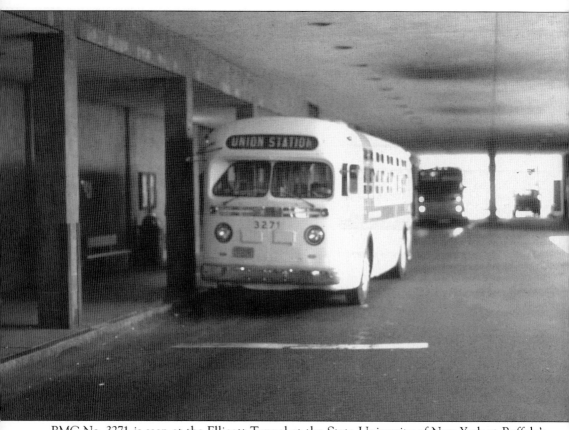

BMC No. 3271 is seen at the Ellicott Tunnel at the State University of New York at Buffalo's North Campus in 1988.

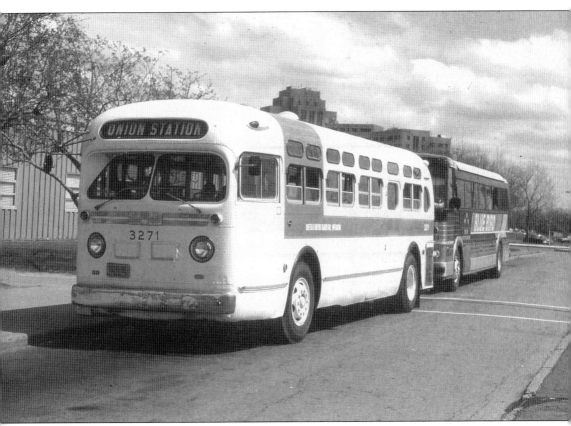

BMC No. 3271 is seen at Diefendorf Circle in 1988.

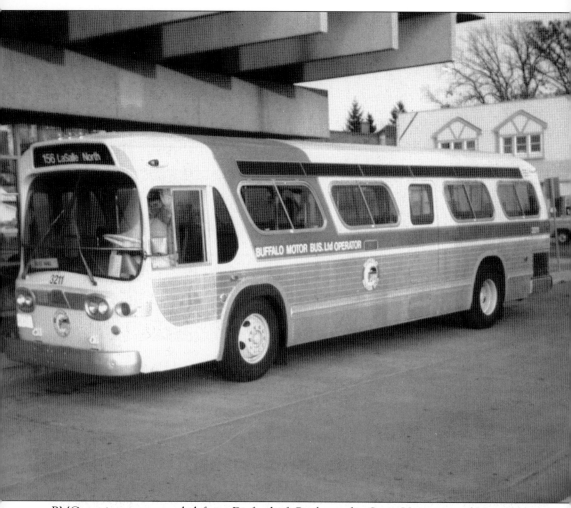

BMC service was extended from Diefendorf Circle at the State University of New York at Buffalo South Campus to the LaSalle Metro Rail station in September 1991. In November 1991, No. 3211 departs for the North Campus of the State University of New York at Buffalo via the Boulevard Mall.

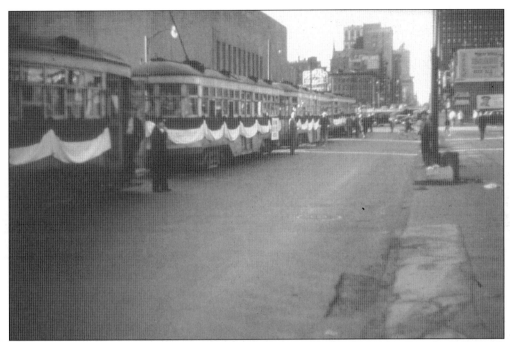

This page features contrasting views of the same location. In the above photograph, on June 18, 1950, the last IRC streetcars to operate on Main Street stop in front of Memorial Auditorium to discharge final passengers. The lower photograph shows the same location on May 18, 1988. A special four-car Metro Rail train carrying Chicago area transit enthusiasts has stopped at the auditorium station to allow passengers to transfer to BMC No. 3271 for a weekend tour of transit systems in southern Ontario and Toronto.

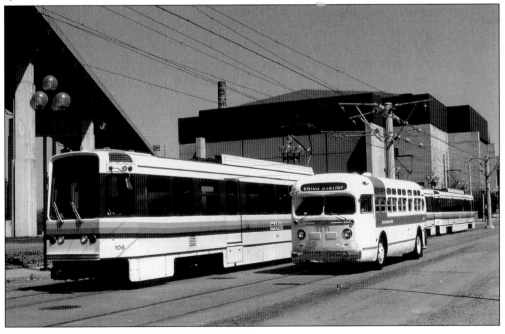

Across America, People are Discovering Something Wonderful. Their Heritage.

Arcadia Publishing is the leading local history publisher in the United States. With more than 3,000 titles in print and hundreds of new titles released every year, Arcadia has extensive specialized experience chronicling the history of communities and celebrating America's hidden stories, bringing to life the people, places, and events from the past. To discover the history of other communities across the nation, please visit:

www.arcadiapublishing.com

Customized search tools allow you to find regional history books about the town where you grew up, the cities where your friends and family live, the town where your parents met, or even that retirement spot you've been dreaming about.

MAP SEARCH